The
Peacock's
Egg

The Peacock's Egg

AN

ALCHEMY

OF

LIGHT AND SHADOW

RON WYMAN

Published by

Mandrake of Oxford

PO Box 250

OXFORD

OX1 1AP (UK)

A CIP catalogue record for this book is available from the British Library and the US Library of Congress.

Contents

Anatomical Illustrations

Preface

The Vision of the Peacock's Egg occurs at the midnight of the alchemical *opus*. It is the illuminated moment when the mercurial light of the vessel is revealed in its coloured splendour. This vision is the practitioner's image of soul and spirit, which is also the human daemon.

The primary interest of this book lies in the practitioner and the *Opus* or Work, this consisting of stages undertaken to arrive at levels of attainment. Understandings of the *opus* and its attainments are described here in practical, alchemical, and philosophical terms.

This book arose from a complex series of experiences and from several years of work. The visual information presented was realised within a long and arduous process, slowly and gradually. This involved a particular kind of visual imagination, unconscious formations, and intuitive struggle for knowledge.

The influences involved here include Nietzsche, Heidegger, Jung, Carlos Castaneda, Alchemy, Shamanism, Rosicrucianism, Kabbalistic mysticism, and Eastern mysticism and martial arts.

There is also some influence from Goethe and Schopenhauer's colour theories.

A main issue in this text is human energy. Increase in one's own energy, that which belongs intrinsically to oneself, is accomplished here through a purification, because its losses and decay are thought to be generated largely through an impurity. This impurity is caused through the existence of other persons' energy or of foreign energy. This purification or *katharsis* is the purgation of one's alchemical soul, or of a metaphysical anatomy, described here and paralleled to the alchemical vessel.

The alchemical *opus* then involves and comprises an extensive and engaging occult philosophy, that centres on an image of human metaphysical anatomy, described here as the Peacock's Egg, understood as light and as the essential nature of human being. The abilities to accomplish the attainments described here then involve particular senses or feelings for a sublime side of ourselves, described here through an occultism.

The initiation of these practices requires the accomplishment of dreaming experiences as described by Castaneda. *Dreaming*, as he emphasises it to distinguish it from normal dreams, consists in accomplishing an arrested attention and objectification of lucid dreams, that comes about through an extremely intensified and persistent psychic forcefulness. It involves the transformation of dreams into real, or seemingly real, situations to the point of being very close to that experienced in reality. This arrives at dreaming perception with panoramic, clear, stable objectivity, including solidity of things, and with bodily control and experience of the five senses.

There is total consciousness as in waking life with conscious decision making and movement, sometimes for long periods of time, even with memory of waking life. There is also the seemingly physically real experience of weather conditions, including wind and warm sunlight, sometimes walking, for instance, in vicinities for long periods of time. Other persons and natural beings take on a realness of appearance and behaviour, and independence of behaviour that can be indistinguishable from waking life. Flying and levitated kinds of movements are also natural movements in this kind of *dreaming*. And there is deliberate bodily movement from one dream to another, and even frightening situations requiring effort to exit *dreaming*.

Waking life may then be affected by these dreaming practices, which can involve waking up while being partially in a dream, and, on more advanced levels, the possibility of alterations of awake visual perception, in which what seem to be tableaux or scenes replace the normally perceived world. Another result is the experience of extremely real, so-called 'out-of-body' experiences, which may occur within the context of one's normal space and time. *Dreaming* perception is developed to a point where it is at times difficult to tell the difference between it and reality without a reckoning with oneself. The experience of *dreaming* is as if being in a world. This is usually somewhat surreal, and which most often seems to contain some slight missing element that keeps it from being a totally concrete world, but which comes close to reality to the point of being almost indistinguishable. And the purification described here, in a way that is reciprocal or linked to *dreaming*, increases the ease, frequency, and power of this *dreaming*.

Presented here is a detailed visual description of a human metaphysical anatomy. This anatomy includes four basic areas, each containing a complex system: a body of light or energy identical in form to the physical or corporeal body, a dual set of extensions located at the midriff area, an encasement or egg surrounding the body, and a system of reservoir areas containing 'expended' light of the body. This anatomy is described with illustrations and definitions within a system of colours. These colours were imagined in a visceral way, where this imagination was somewhat dependent on a painter's experience with colour. The colours presented here, however, are a direct representation of the potentialities of the human soul and its activities, and are not an artist's subjective creation.

This coloured metaphysical anatomy is the place in which our psychical and physical life are based; the place where our psychological life is determined, and where our physical health is determined. It is also the place where emotional and psychological affectiveness between persons takes place. The trace of difference in the human psyche, as a trace of the other, or the psychological trace, often discussed and debated within contemporary philosophy and psychology is, in truth, the affectiveness taking place within this light, in its permanence. The images contained here, however, are intended mainly to convey the manifestation of this light as a kind of feeling and utilisable formation of appearances for the purposes of a praxis. These images are practical devices for the control of something invisible. But this control brings a freedom from the psychological effects of other persons, extending from childhood to the present. It also means the reversal of the physical decay of the body, including the bone structure, muscles, and

internal organs, which means physical strength and health, and which is, of course, not a reversal of physical growth or of any maturation. This process of purification and rebuilding has gradual and also immediate effects, which are both physical and psychological. And it continues in an intensive manner for years, the extent of which depends on the person, but which will always continue indefinitely in some form.

What occurred was that I was able to very succinctly draw definite quantities of my own energy from an abstract entity, which had been expended at some point in time. This allowed me to visualise and map, based on a kind of visceral clairvoyance, something very elaborate, *which became more accessible through its image*, and which involves all aspects of human affecting and attention. This ability was arrived at, I believe, because of *dreaming* practices. This then led me to understand that something systematic was taking place, and that human energy has an extensive and definable collection of colours, casts, and consistencies which may be associated with it. These have consistent behaviours based on their types and their psychic expenditures from within the human body, and based on their effects within this anatomy. This in turn allowed me to understand that a purification and renewal could be arrived at, through a reversal of its activities or movements of energy; because exchanges of human energy involve more or less permanent losses from this anatomy, as exchanges are either stored or digested within it, or assume an effective place within it causing further losses. Though the anatomy I arrived at may seem strange or random at first sight, upon careful examination one will find that it is not; it is something harmonious, and ultimately real and primary.

This anatomy is associated with alchemy as a Vision of the Peacock's Egg. The peacock is a significant bird in alchemical symbolism, associated here with the mercurial substance in its states of coloured light, intrinsic to the human soul. The male peafowl is associated with the egg because of his plumage, and because these alchemical birds are thought of as hermaphroditic fowl, associated with Hermes-Mercury within the Western Hermetic tradition. This vision is also associated with Nietzsche as being a basis of Zarathustra's 'most abysmal thought'; the midnight 'thought' that precedes the dawning of a personal transformation. Its details were accumulated and arrived at through a deep silence, and a very careful and sometimes intense but quiet seeing of this mercurial and ethereal level of human existence.

The basic idea visualised here is that individuals exist within an encasement within an infinity, and that all interactions and experiences in the world take place within that infinite spatiality in terms of light, while in a parallel way they also take place in the world. This parallel of mercurial energy to the world of appearances is an idea that dates back to early alchemy, stated, for example, in the famous Emerald Tablet. It is possible to apprehend this other area of our being, and the concern here is to purify, repair, and regenerate this other side of our being, which then constitutes a parallel relation to the physical world and the human body. The essential discovery is that human beings possess natural phrenic forces which allow for the ability to effectively apprehend and purify this light or energy, and that these forces may be 'awakened.' This also involves the discovery that knowledge of an appearance of that energy allows for a powerful access to it, and that its appearances possess consistencies that are recordable. And despite the obscurity

of this area of apprehension, this peacock's egg, being primary to human existence, is something that everyone already knows, but has, through a necessity and primal enchantment of the human psyche's light, forgotten.

Included here is an appendix medicine and disease. It follows that this anatomy is the place where foreign chemicals and radiation act on the body, and the place where diseases act upon the body and affect it. And then the accessibility of this area allows for the extraction of these, in a shamanic way. The idea with regard to this is that human diseases, injurious substances, and radiation contain, in a similar way as human energy, a metaphysical side to them which is the real basis of their effects on the human body. This idea regarding disease is perhaps one of the oldest ideas in medical history, but which is described through a contemporary occult chemistry theory, and brought into a contemporary understanding.

This book is involved with spiritual or philosophical alchemy. It comprises an occult practitioner's philosophy based in the alchemical *opus*. It is also intended to be adaptable to the practitioner's own works and beliefs, or individual interests, and is presented in a schematic and structural way, allowing for variance of practice. And it is a serious undertaking, that can be difficult and even dangerous to one's well being, and so, is presented with some caution. The initiand steps onto a path, and path of light, that has indeterminable choices and obstacles, but which is also infinite and without limit.

R.W.

I

Anatomy of the *Peacock's Egg* The nature of light

Light described in this book is thought to exist within an infinity, as energy essential to what appears in the world, and to the human eye. In its relation to the human body it belongs intrinsically to the human soul, and is understood through a metaphysical, ethereal level of the human body, and through an aural field surrounding the body. It also refers to what has been thought of as ectoplasm, but does not refer exactly to this interpretation of energy, and does not involve a simple invisible substance. Through the visual nature of the approach taken here this energy is referred to as light. And through this illuminative understanding that carries a nature involving substances this is brought into the context of an alchemical chemistry.

The behaviour of this light differs from that of light or substances existing in the physical world. It may be thought of as a kind of liquid light, but which possesses varying consistencies extending from a crystallisation to a vaporousness. It possesses varying degrees of intensity and has differing weights that may be sensed ranging from a heavy solidity to a kind of light, electrified energy. Its behaviour is not constrained as light and substances are limited within the physical world. It has the ability to expand or contract

itself so that the space it occupies is not easily imaginable in relation to the body. Its differing colours, types, and casts also contain abilities to merge or mix or to be attached without mixing. It also coexists spatially within this infinity on differing levels, individually through its origins, and temporally through its moments of affect. It has within its ethereal nature both attraction and repulsion forces based on its specific properties and psychical attributes, and contains its own movements and behaviourisms based on its properties. These aspects of its behaviour are outlined and defined here to a high degree giving the practitioner a complete and clear view of its nature.

This light, as it belongs to the human body and soul, contains an attachment to the psyche and emotion. Or rather, it is the psyche and emotion itself, including all of the possible psychic types of movements, which may also be defined as human pathos. It generally moves slowly in itself but may also have a kind of electric speed. Its types are most often classifiable in terms of one or two colours, where there is always a dominant colour, and where the light's natural behaviour is also dependent on these one or two colours. It has a life and movement of its own, where it detaches itself or stops its own movement based on its psychical attachments and on its own fluidity. It also acquires its own momentum at times and moves and collects itself in specific quantities and masses. For these reasons its control is an art, natural to sense and understand through experience.

The encasement

An encasement surrounding the body exists within this infinity in the form of ten coloured layers of light. These colours, as well as its interior colours, are symbolised in alchemy as an appearing of the Peacock's Egg. It has the form of an egg and its shell contains these ten layers as condensed or solidified light, which constitutes the earthly and mortal existence of a human being.

The encasement itself has a history in philosophy and mysticism, in ancient thought, and in alchemy, usually referred to as an egg. Manly P. Hall, in an essay on Emerson, notes: "With few exceptions pagan philosophic systems discovered that man exists within the opalescent globe now termed the auric egg, or soul envelope."[1] It is represented by the alchemical vessel, as it is the egg-vessel of Mercury. It may be referred to as the egg, or aural egg, the cocoon, the encasement, the vessel, or as a receptacle, or shell. It is illustrated in the 17th century alchemical woodcut and engraving shown opposite, and on page 20.

In Kabbalistic theory the "brilliant shell,"[2] or *kelippath nogah*, is the dark and 'evil' shell of the Other Side, filled by the light of the *Sephiroth*. This is the incarnation of the *Sephiroth*, which may be associated with the human body. This shell belongs to a counter-world that has varying interpretations through Kabbalistic history, also a Luciferian world.

The appearing of the Peacock's Egg is also associated with Zarathustra's vision in Nietzsche's *Thus Spoke Zarathustra*, in the section 'On the Vision and the Riddle.' It is an appearing of a

vision of the alchemical peacock's iridescent colours, of this luminous vessel-egg, and haunting flower-like egg, that initiates the practitioner onto a path toward the *lapis*.

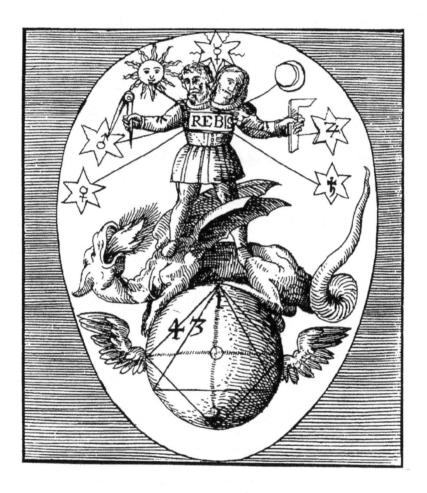

Herbrandt Jamsthaler, from *Viatorium Spagyricum, 1625*.

Michael Maier, Emblem VIII, *Atalanta Fugiens*, 1617.

The encasement light

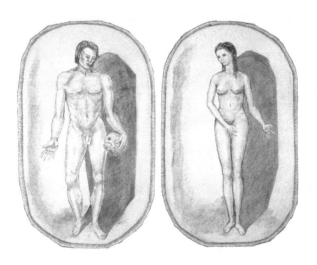

The encasement consists of ten layers, listed here beginning with the interior and moving out to the exterior:

1	2	3	4	5	6	7	8	9	10
Grey	Black	Violet	Tur-quoise	Mars Red	Silver	Copper	Clear	Gold	White →
			Forest Green	Brown					
				Pink					
			Cobalt Blue						

The colours are always in a particular state, which is not that of a spectrum except in the cases of violet and white. It contains a kind of altered, circular spectrum of grey, black, violet, blue, green / red, orange, yellow, white, where a metallicism occurs in the exterior layers. The silver light or mercurial metallicism and the clear light mix with the orange and yellow layers, hence the copper and gold. The metallic light and what might be seen as a kind of silver and gold mysticism within this anatomy are explained by this silver light being mixtures of varying consistencies of the clear light with black and white, or grey.

All ten layers possess an inner and an outer layer, where the inner layers are composed of a denser, more intense energy than the outer layers. The consistency of the encasement energy is difficult to describe but important to know. The energy of the outer layers has a soft, somewhat heavy, liquid nature, where this energy seems to move or dissipate in small flakes or pieces that also merge together. The inner layers are composed of a similar energy that is distinctly more dense and seems to dissipate in smaller particles.

The energy of both the inner and outer layers also have a rough or rugged feeling.

There are two further aspects to the encasement layers. Along with the inner and outer layers of the encasement, each layer also has petals of light. They wrap from a kind of rootedness behind the spinal column, around the sides of the encasement to the front, and include numerous layerings of these petals for each of the 14 encasement colours. Their rootedness is contained within a kind of crevice that extends from the top rear of the encasement to the bottom rear. They are always single, full-sized petals that wrap around either side of the encasement. Each petal covers an entire half of the encasement, extending from the top to the bottom of the encasement and from the rear crevice to the front of the encasement. And the other further aspect of the encasement light is the existence of whole, egg-like forms of each of the 14 colours. They are thin, multiple layerings, something like balloons, that cover the whole encasement.

The shape of the encasement fluctuates somewhat, and it is connected to or parallel to the body based on the central core and spine of the body. The encasement partly constitutes the physical, corporeal body, particularly in its physical structure. And the physical body decays as the encasement decays. The inner and outer layers decay as a kind of erosion, the petals peel or fall off of the encasement, and the balloons fall off or pop off of the encasement in whole forms. The encasement also collapses or is relinquished at the time of physical death.

The encasement colours may all be considered serene, some commonly found in nature. A further description of them follows:

1. The grey is a light grey.

2. The black is a pitch black.

3. The violet is a neutral or pure violet, and includes extensions into small violet disks in the upper areas of the back of the encasement, as illustrated on page 24.

4. This layer has a format illustrated on page 24. The turquoise covers the front of the encasement, the forest green covers the back of the encasement, and the light, cobalt blue is at the top section of the back of the encasement, surrounding the violet disks.

5. This layer also has a format illustrated on page 24. The mars red covers the front of the encasement, the brown, which is a rich or lustrous dark brown, such as the colour of dark coffee beans, covers the back of the encasement, and the pink, which is a light, rosy pink, is at the top section of the back of the encasement surrounding the violet disks.

6. The silver is a bright silver.

7. The copper is a warm, clear copper or bronze, with a dark orange quality.

8. The clear is a clear substance which mixes with the other layers.

9. The gold is a bright gold.

10. This outer layer is a bright white which can be thought of as appearing like snow. There is an important additional glowing white surrounding this layer, which has an airy, slightly metallic nature or feeling.

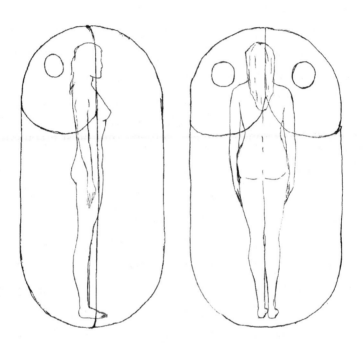

The amber

There is an amber substance, which is a special kind of energy that normally exists on the exterior of the encasement. It is something like honey in its look and feeling of consistency and substance, and it has an internal layer, which is something like honey comb. This layer also has a petal aspect, and balloon aspect, as described above. It does not belong to the other layers exactly, and its

expenditure is not a decaying of the same kind. This amber light is discussed in chapter IV. It has special aspects related to the perspectival and balancing nature of this anatomy.

Light within the body

Light within the body itself is perhaps as complex in behaviour as human physical anatomy. As a whole it may be imagined as a body of light identical in form to the physical, corporeal body, and as being superimposed onto or contained within the corporeal body. This body consists of circulations of energy, most of which have a vortex nature.

These vortices vary in size wherein large vortices exist in the spaces of the major internal organs. Their vortex nature accounts for the existence of large quantities of energy within the body. The idea of their existence here originated from Castaneda, which becomes undeniable through this purification praxis. Their placement, size and shape is important to know and visualise for the expulsion of undesirable energy. Throughout one's life energy is drawn into them and remains there, where this energy is the cause of inescapable necessities to expend one's own energy, because of the agitation, impurity, or force it causes within the vortices. The vortices contain an infinity in themselves as their energy extends seemingly deeper than the space they physically occupy. When other persons' light, or foreign light, enters them it situates deeply there and may have permanent psychical or physical affects. This light extends behind the vortex to other areas of the anatomy, whereas one's own vortex

light compacts itself within the vortex's infinity. Undesirable light will maintain a permanent base-point within the vortex but will extend itself throughout the body or outside of the body.

Varying colours and consistencies of light expend from within these vortices. Energy acquires colour and consistency upon its expenditure, which is the vibrant nature of its presence that gives it its affective powers. For the purposes of purifying and renewing energy the important matters are the positions, shapes, and sizes of these vortices, which are conical, spherical, or cylindrical. Energy is then expelled from the vortices by focussing on them as base-points of intrusion, following which they naturally and immediately replenish themselves.

The conical vortices

The vortices referred to in this subsection are all cone-shaped. There are described here 100 major conical vortices, summarised in a list of 50, as some belong to couples of the left and right sides of the body, or are designated as pairs. The major conical vortices are as shown on pages 28-30:

The midriff and back

1. One at the heart which is around the size of the heart.

2. A pair at the liver extending directly inward, as a double vortex.

3. One on each side of the lower abdomen, which are the largest vortices in the body.

4. Two at the lower back, located along the spine.

5. One at each side of the chest beneath the arms, at the lungs.

6. A pair at each kidney and adrenal gland, extending directly inward, as a double vortex.

7. One at each side of the abdomen.

8. One at the upper back near the neck, extending slightly downward.

9. A pair at the spleen extending directly inward, as a double vortex.

10. One at the upper centre of the chest at the thymus.

11. One at the upper back located on the spine.

12. One at each side of the ribs, behind the liver and spleen, which are relatively small vortices.

13. One within each clavicle.

14. One at each side of the outer front of the lower abdomen.

15. One below each side of the lower abdomen.

16. One at the centre of both the upper and lower abdomen.

17. One on each side of the upper front of the abdomen.

18. One on each side of the lower front of the abdomen.

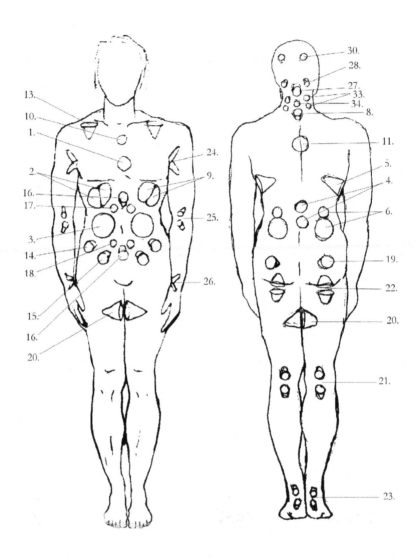

The arms and legs

19. One at the centre of each buttock.

20. One within each inner thigh extending slightly downward.

21. A pair within each leg at the knee joint; one extending upward into the lower thigh and one downward into the upper calf.

22. A pair at the back of the upper legs; one extending upward into the buttocks and one downward into the upper thigh.

23. A pair at the ankles; one extending upward into the lower calf and one downward into the heel of the foot.

24. A pair within each armpit; one extending upward into the shoulder and one downward into the upper arm.

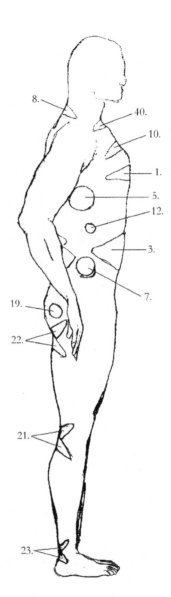

25. A pair within each elbow joint; one extending into the upper arm and one into the forearm.

26. A pair at each wrist; one extending into the forearm and one into the palm of the hand.

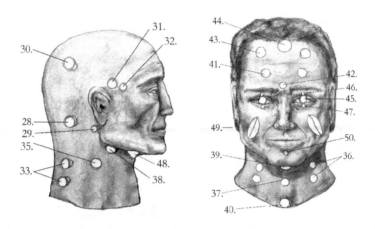

The head and neck

27. One at the base of the back of the head extending slightly upward.

28. One on either side of the lower back of the head.

29. One on each side of the head behind the ear lobes.

30. One on either side of the upper back of the head.

31. One at each temple extending directly into the head.

32. One on each side of the head behind the eyes.

33. A pair on either side of the back of the neck.

34. One at the rear centre of the neck.

35. One at each side of the neck.

36. A pair on either side of the front of the neck.

37. One at the centre of the neck, at the thyroid.

38. One on each side of the neck below the jaw.

39. One at the upper frontal centre of the throat.

40. One at the lower front of the neck, at the suprasternal notch.

41. One at each side of the front of the forehead.

42. One at the lower centre of the forehead.

43. One on each side of the upper forehead.

44. One in the centre of the upper forehead.

45. One at each eye socket, the size of the eye, extending into the head.

46. One above each eye extending slightly upward.

47. One beneath each eye.

48. One beneath the chin extending slightly upward into the head.

49. A pair at each cheek extending into the head, as double vortices.

50. One above the chin.

Note: Women have additional vortices at the breasts, extending inward behind the sternum. Men have an additional vortex behind the genitals.

The cylinders

A level of the body exists as circulating cylinders. This level coincides with the vortices level of the body but is accessed and treated separately. This cylindrical system has two aspects: outer cylinders that circulate around and through the entire physical body, as shown on page 33; and a central, inner cylindrical system within the core of the head and torso, extending from the top of the head to the groin, as shown shaded in black. The outer cylinders are not vortices but are coils and rungs of light, made of fine, intensified energy that decays, and will repair by fortifying their energy and tightening their forms. These include circulations around the central cylinder with a broad area at the abdomen; cylinders of the head; conical, cross circulations extending into the abdomen and into the head at the face; cylinders at the left and right chest areas; and, cylinders extending along each arm and leg. The inner cylinders vortices include a central cylinder with conical vortices at each end; a central spherical vortex at the centre of the gut with a cylinder extending through it from front to back; spherical vortex within the chest with a horizontal cylinder at the base of the sternum extending through the body; a disk-like cylinder within the neck with a central spherical vortex, and a cylinder extending through the head at the ears with a central sphere within the head.

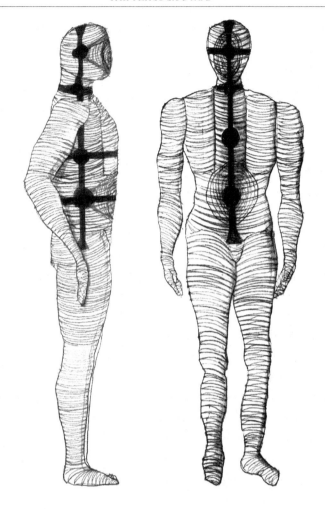

The frontal quarter

The interior, front upper quarter of the encasement is a particularly susceptive area of this anatomy. There are nine spherical areas of energy, and two cylindrical areas here, in front of and above the body, as shown on page 34. Other person's and foreign light accumulates in them and may extend into the body or within the encasement while being based in these centres.

Seven of the spheres stand floating in front of and above the body, as shown, while two are situated within and in front of the eye sockets. At the upper left and right of the encasement exist cylinder vortices, which extend both into the interior and outward to the exterior of the encasement. These cylinders are bases of affective light, which enters the spatiality of the anatomy, interior or exterior to the encasement, without having directly affected the anatomy or entered the body. In this way light that is based here is atmospheric in its affects.

Included within this frontal space is a thick area of accumulation in front of and adjacent to the body, extending from the top of the head down the front of the body to the lower midriff, and out to the encasement.

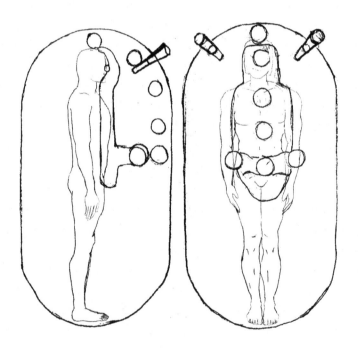

The corporeal body

The corporeal or physical body has its own invisible light directly immanent within its tissues and substances. It is light identical in form to the physicality of the body, created and coloured as the physical body is formed and renews itself. It is always a bright or brilliant energy, saturated as if it contains a clear or oily substance, and generally has a harsh consistency. It may be accessed in its entirety through all of the nine basic and spectral colours, black, violet, blue, light green, dark green, red, orange, yellow, and white, plus the pink, grey, brown, clear, and silver. A table of this light is shown on page 105.

The following is a designation of areas of the body utilised for specific focus when undergoing a purification. The body is separated into its various areas here based on the body's systems. It is a suggested application or reminder, where the discretion of the practitioner should be involved:

The skeletal system; the muscular system; the skin; the nervous system, including the spine and brain; the circulatory system, including the heart; the respiratory system, including the trachea and lungs; the digestive system, including the stomach, liver, gallbladder, and upper and lower intestines; the urinary system, including the kidneys and bladder; the reproductive system, including the genitals, male prostate, and female ovaries and breasts; the glandular system, including the pancreas, adrenals, pituitary, hypothalamus, and pineal gland; the lymphatic system, including the thymus and spleen; the head in general, including the nose, mouth, eyes, and ears.

Expended light

There are two types of spatial movements of expended light or energy: that which simply remains within one's own spatiality and anatomy, and that which extends into other persons' anatomies. The former accumulates within specific and consistent areas within one's own anatomy, and the later does the same within others' anatomies, if it is not permanently effective on the person's anatomy.

This expenditure maintains itself within one's own space or within identical areas of other persons. If it is internal light it accumulates in reservoir areas, based on the colour and consistency of the energy. Encasement light erodes from the encasement layers and either hovers outside of the encasement or accumulates on others' encasements.

The reservoirs

Reservoir areas exist within the containment of the encasing primarily against or near its inner surface. Light accumulates in these areas as it is expended from within the body, and these areas are visualised for the retrieval of light into the body. The spatial placement and positions of the reservoir areas is the same for everyone. Light from the body expends and allocates itself within these reservoirs based on its colour or consistency, and will either rest within one's own reservoirs or exchange and rest in the reservoirs of others. The sizes of these reservoir areas changes with accumulated light. However, the light of individual persons does not intermix, and remains on separate levels of existence

spatially. Light from either side of the body will remain on the same side of one's own encasement as it is expended, but will go to the opposite side of others' encasements as it is exchanged. And the larger quantity of light will generally expend from the right side of the body.

There are three levels of consistency to this light: a substantial level which gradates from a crystallised state to a light substantiality, an insubstantial level referenced here by the suffix 'ness' (e.g. blackness), and a lighter, airy insubstantial level referred to as vaporous. In this way colours gradate from deep or 'heavy' and crystallised states to lightened and vaporous states within the reservoirs. The substantial colours have a consistency and feel like paint or a semi-thick liquid that also crystallises. The insubstantial colours possess a kind of dryness or flatness, like thin paint, or like paper material that could be decomposed and formed, except for a clearness light which is like thin oil. The vaporous light is airy, and has two types: one is like a light mist, and the other possesses a dry lightness. A silver light also forms and always has a dense or heavy weight and force and may be described as metallic energy. Its expenditure belongs essentially to a reservoir below the encasement, which will be described separately.

Most of the colour reservoirs have a blackness base from which they extend. The insubstantial colours blackness, whiteness, and greyness function within the psyche, along with the clear light, as a non-emotive basis of the coloured light, and all substantial and vaporous light. The clear light has an insubstantial, clearness level and also crystallises and liquifies or vaporises. Blackness, whiteness, and greyness mix with every consistency of the clear light, but

only with the insubstantial level of the colours. They also form a silver or mercurial mixture which behaves as a separate energy.

There are eight basic internal colours, including white, black, blue, violet, red, green, yellow, and orange, plus the clear light. Greys, pinks, and browns also form and take on their own precedence, as do silvers. The green light is distinguished on an elementary level as a light green and a dark green and separates itself as such, giving nine basic colours. These basic forms of energy then mix to form more complex colours. They collect in deep and crystallised states, or in their basic states, and some heighten as yellow tonalities or pale-white tonalities. They also mix in dark tones, as brown tonalities, or as colours mixed with compliments, grey, or black, referred to here as 'shaded' tonalities. In general, these darker tones exist at the bases of the reservoirs, while the lighter tones collect near the ends as the reservoirs extend from the blackness. The deep and crystallised states also tend toward the bases of the reservoirs while the lighter states exist toward the ends, and the vaporous light exists at the surfaces of the reservoirs. And the colourness light tends to accumulate in the interior of the reservoirs. The hardened or crystallised clear light and the vaporous clear light accumulate in separate reservoirs at the bottom of the encasement, as they are the only light of these consistencies that mix with the other colours. The emotive details of the differing colours are discussed in chapter III. All of these colour combinations are also shown in tables on pages 102-104.

Regardless of the existing colour combination of this light it is only necessary to know the colours singly or in double combinations. There is either a single colour or a dominant and

secondary colour, and knowing this allows for access to the energy regardless of other mixtures involved. In theory energy colours and mixes when it is expended from the body following which it collects in these reservoirs according to its dominant colour.

Descriptions of the reservoir areas follow and are illustrated on pages 42 and 43. Each of areas 1 through 12 have an attached sphere. These spheres are important as they contain base-points of light contained in the reservoirs when it detaches from its origin as it is exchanged between persons, which will be discussed. The collections at the bases of the reservoirs contain the brown and shaded tonality of the colour, which includes reservoirs 1 through 8 plus 10. Each area always contains the colour or its mixtures with other colours, where the colour had been dominant within it at the time of expenditure. Each of reservoirs 1 through 12 include a vaporous light of their respective colours which surrounds it. Asterisks (*) indicate reservoirs illustrated on page 42 as they exist for the left and right sides, as these are reservoirs which do not separate for the left and right, though this may be an illusion created by the closeness of the light. The remaining reservoirs are illustrated here only for the left side. Areas numbered 2, 3, 4, 8, 9, 10, 12, 16, and the spherical segments shown enter the interior of the encasement. Page 43 illustrates the left and right sides as viewed from the front and back of the encasement.

1) *Black* extending from a deep or heavy and crystallised state, and black-brown, to a tonality of each of the nine basic colours, minus white and black, plus pink, grey, clear, and silver, with a blackness centre, and vaporous black surrounding. These include an attached sphere.

2) *Violet* extending from a deep and crystallised state, and shaded violet and violet-brown and shaded state, to a pale violet-white and a violet-yellow, plus a violet-clear and violet-silver, with a light violetness centre, and vaporous violet surrounding. These includes attached spheres, which are the same spheres as are attached to the brown reservoirs, though the violet and brown do not mix within them.

3) *Blue* extending from a deep and crystallised state, and shaded blue and blue-brown, to a light blue and blue-green and pale blue-white, plus a blue-clear and blue-silver, with a light azure or blueness centre, and vaporous blue surrounding. These include attached spheres, which are the same spheres as are attached to the white reservoirs, though the blue and white do not mix within them.

4) *Green* extending from a deep and crystallised state, and shaded green and green-brown, to a pale green-white, and a green-yellow, plus a green-clear and green-silver, with a greenness centre, and vaporous green surrounding. There are two green reservoirs on each side of the encasement: upper reservoirs extending through the thighs and lower reservoirs extending through the calves. The upper reservoirs contain a light green and its gradations, and the lower reservoirs contain a darker green and its gradations. These all include attached spheres.

5) *Red* extending from a deep, blood red and crystallised state, and shaded red and red-brown, to a light red and red-orange and pale red-white, plus a red-clear and red-silver, with a redness interior, and vaporous red surrounding. These include attached spheres.

6) *Orange* extending from a deep and crystallised state, and shaded orange and orange-brown, to a light orange and orange-red and orange-yellow, and pale orange-white, plus an orange-clear and orange-silver, with an orangeness interior, and vaporous orange surrounding. These include attached spheres.

7) *Yellow* extending from a deep and crystallised state, and shaded yellow and yellow-brown, to a light yellow and yellow-orange, and pale yellow-white, plus a yellow-clear and yellow-silver, with a yellowness interior, and vaporous yellow surrounding. These include attached spheres.

8) *White* * extending from a deep or heavy and crystallised state to a tonality of each of the nine basic colours, minus the black and white, plus pink, grey, clear, and silver, with a vaporous white surrounding. This includes attached spheres, which are the same spheres as are attached to the blue reservoirs, though the blue and white do not mix within them.

9) *Grey* * extending from a deep and crystallised state to a tonality of each of the nine basic colours, plus pink, clear, and silver, with a vaporous grey surrounding. This extends around the lower back, and includes attached spheres.

10) *Pink* * extending from a deep and crystallised state, and shaded pink and pink-brown, to a pink-orange-yellow and pale pink-white, plus a pink-clear and pink-silver. This includes a single attached sphere.

11) *Brown* extending from a deep and crystallised state to a tonality of each of the nine basic colours, plus the pink, grey, clear, and silver. This includes attached spheres, which are the same spheres as are attached to the violet reservoirs, though the violet and brown do not mix within them.

12) *Clear* substance containing a tonality of each colour, plus the silver. These extend around the body and include attached spheres.

13) *Crystallised Clear* * light containing a tonality of the crystallised light of each colour.

14) *Vaporous Clear* * light, or airy clear light containing a tonality of the vaporous light of each colour, minus the silver.

15) *Blackness* containing a colourness tonality of all colours as it approaches the individual reservoirs, minus the blackness and whiteness.

16) *Whiteness* * containing a colourness tonality of each of the nine basic colours, minus the black and white, plus grey, pink, brown, and silver.

17) *Greyness* containing a colourness tonality of each of the nine basic colours, minus the grey, plus pink, brown, and silver.

18) **Clearness** * containing a colourness tonality of each colour, minus the clear light.

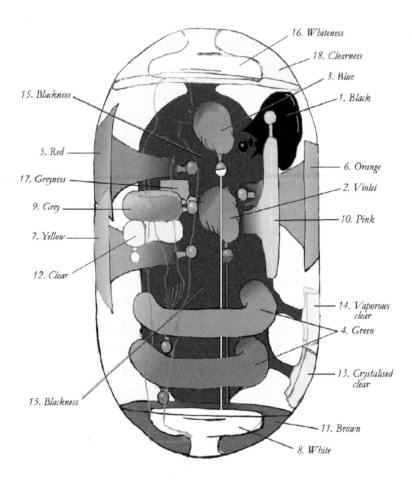

16. Whiteness

18. Clearness

3. Blue

15. Blackness

1. Black

5. Red

6. Orange

17. Greyness

2. Violet

9. Grey

10. Pink

7. Yellow

12. Clear

14. Vaporous clear

4. Green

13. Crystalised clear

15. Blackness

11. Brown

8. White

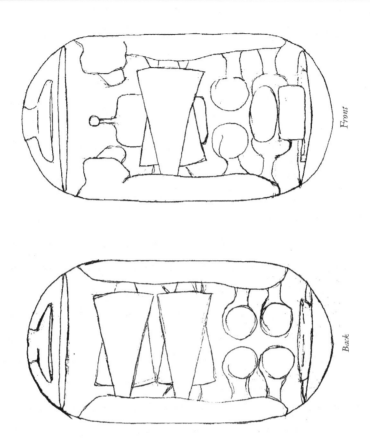

Reflective light

The blackness, whiteness, and greyness light may be understood as reflective light in reference to the reflective and perceptual nature of the psyche. The place of the blackness reservoirs has already been described, and the whiteness and greyness light collects in separate, individual reservoirs.

The lower reservoirs involve energy which is spinal and of the lower spinal area while the upper light is cerebral. This light also mixes to form an intense mercurial-silverness light.

43

There are nine cone-shaped reservoirs of whiteness light, as shown below. They are left and right reservoirs containing whiteness energy that mixes with the four types or levels of clear light, plus a single central whiteness reservoir containing a mixture with the silverness light. They contain mixtures with the clear light of their respective clear consistencies with blackness-clear bases of the same respective clear consistencies. These four levels of clear light, moving from upper pairs to lower pairs, are clearness, substantial clear, vaporous clear, and crystallised clear, including a lower single, central pool containing a silvery mixture of whiteness light, as shown.

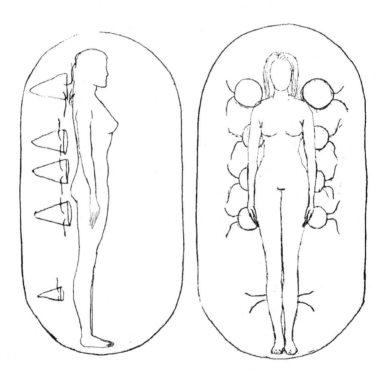

Aligned with the whiteness reservoirs are eight reservoirs of greyness light, also containing mixtures with the clear light on the same levels, as shown.

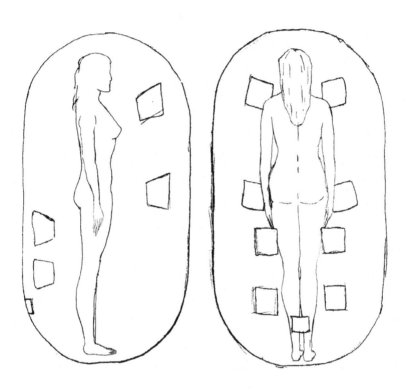

In this way the blackness, whiteness, and greyness all contain mixtures with four levels of clear light within reservoirs on equal levels within the interior of the encasement.

Silver light

The silver or mercurial energy expends from the vortices and spinal column and from deep within the body. Internal light may be attached to this silver light or tinted by it, in a similar manner as the clear light. It has a heavy quality and its collection occurs below the base of the encasement, as shown. This reservoir contains a central core or silver sphere. There is also a relation between this energy and the lower whiteness and greyness reservoirs, and lower blackness reservoir area that it is connected to, as shown.

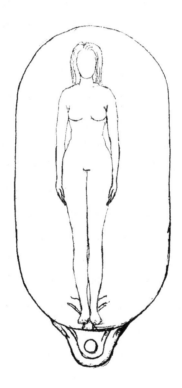

The external fragments

Surrounding the encasement there are layers of expended light consisting of clusters and fragments of the encasement energy, as shown. They are areas containing decayed encasement light that hovers around the exterior of the encasement. All of the types of encasement light can exist in these areas. The decay of the petal light also remains in this area and accumulates at the back of the encasement, as shown.

The colour spheres

The colour spheres within the interior of the encasement, described on pages 39-42, are illustrated here, including large redness spheres that exist in front of the chest area. The spheres contain base-points of light contained within the reservoirs that has detached from its origin. And the redness spheres contain base-points of the blackness, whiteness, and silverness energy, and of all colourness light, which will be described below in detail.

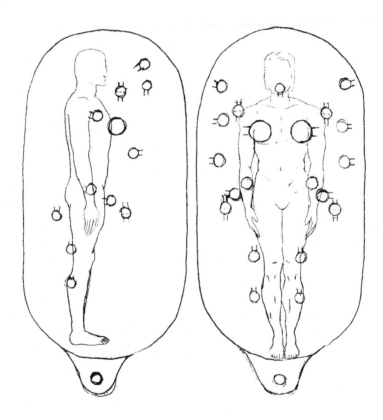

The red and gold suns

Redness spheres exist in front of the upper chest, as shown on page 50, referred to here as the red suns. They contain base-points of all colourness light. They are predominated by the dry redness light, and possess all of the consistencies of the red reservoirs, as a redness type of light, in a redness form. Within these gradations exist all of the other types of colourness light, and there exists separate, small blackness, whiteness, greyness, and silverness spheres surrounding them. In this way all of the colourness light of the interior reservoirs of the anatomy have base-points within these red suns and their surrounding spheres. And the redness energy then accumulates around the upper body, as shown.

Two gold spheres exist outside of the encasement at the upper left and right, as shown on page 50, referred to here as 'gold suns.' They stand in front of the upper cylinder vortices of the frontal quarter. They contain base-points related to the encasement light.

The red suns contain layers of light, as shown:

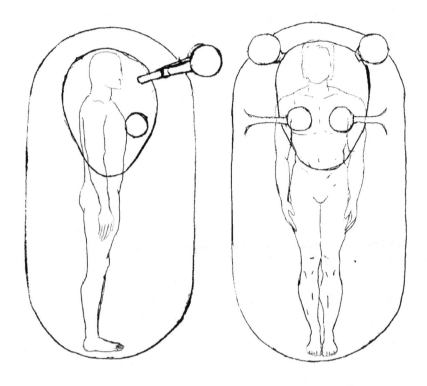

These spheres contain gradations of redness light that exist within this anatomy as an extension of levels of light beyond that of the other colours. They include 15 gradations of the redness light, including a blackness-redness, greyness-redness, clearness-redness, whiteness-redness, silverness-redness, crystallised redness, deep redness, redness-brown tonality, shaded redness, redness, redness-yellow tint, redness-white tint, redness plus clear, redness plus crystallised clear, and a vaporous redness. The redness radiates outward as the light becomes less heavy and substantial. These colours are also listed in the table shown on pages 103-104. The spheres contain these gradation as follows:

1. Small, solid inner cores of intense colourness-redness, including the blackness, greyness, clearness, whiteness, and silverness-redness.

2. All of the remaining gradations of the redness light, excluding the vaporous redness. This area includes all 13 types of the other colourness light of the entire anatomy, each as a full sphere of light.

3. The vaporous redness light. This area includes all 12 types of the other vaporous-colourness light of the entire anatomy, each as a full sphere of light.

There are 14 colourness spheres surrounding the red suns, that include whiteness, blackness, greyness, and clearness light unaccounted for in the interior of the red suns. These, combined with the red suns, account for all of the colourness light.

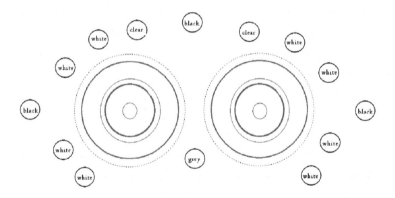

The gold suns contain the base-points for all encasement light that detaches from its origin. The gold and amber on these spheres give them the appearance of a gold exterior, since the white here is less dense than it appears on the encasement. The gold suns contain eleven layers of light, as shown on page 52:

They include an inner core of grey, and layers of black, violet, turquoise, forest green, cobalt blue, mars red, brown, pink, silver, copper, clear, gold, white, and amber.

The frontal attachments

There exists an additional peculiarity at the frontal right and left of the interior of the encasement, consisting of spectral colours, violet (2), blue (3), light green (4l), dark green (4d), red (5), orange (6), yellow (7), and white (8), plus black (1), grey (9), pink (10), brown (11), clear (12), and silver (19); as shown on page 53, and as numbered here and on pages 39-42. These formations differ for men and women, as shown. They are accumulations involving a familiarity, agreement, or psychological attachment on the sublime level of this anatomy, when exchanged between persons. These arrangements of colour are determined by the sex of the originator and not by the holder, so that the two arrangements will coexist within the encasement. The upper square areas are attached to the black substance areas illustrated on pages 42 and 43. This energy will remain in these positions within the encasement when its exchange is reversed.

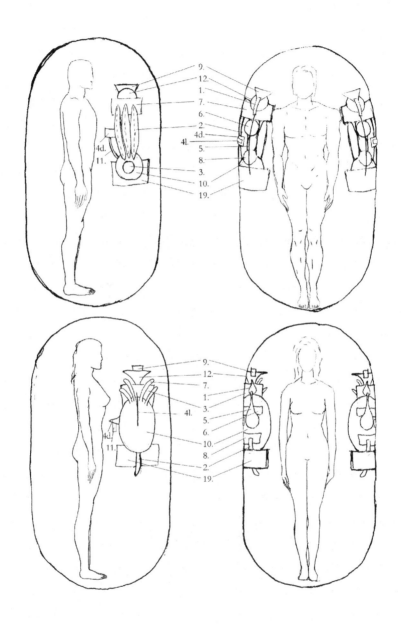

The far clusters

There exists spheres, as clusters of bright light, behind the encasement to the far right and left, as shown. These are base-points of the brilliant light that expends and is lost from the physical body itself.

The viscera

The midriff area of the body contains an important metaphysical side of ourselves. It is what the Greeks referred to as *phrên* or the *phrenes*. This metaphysical side of the viscera is sensed or vaguely known by everyone through emotions and visceral experience. An ability to refine or control and intentionally utilise this level of

ourselves is possible. This has a history in Eastern mysticism and martial arts, and has been associated with clairvoyant abilities in Western thought. Here a visualisation and specific defining of it is presented.

This phrenic area is the place of the impulse, and the intentional impulse in a deep, bodily and psychical sense. It is also the place of the initiations of the expenditure of energy in an intentional sense, and the place where initial effects takes place on an immediate level, as the place of the initial stirring of energy in a reactive sense. Most expense of psychic energy begins as a reaction in the midriff, whether or not consciousness is involved, and however subtle a reaction may be. Psychical energy has its central and most immediate impulsive and reactive origins in the viscera, which is also a hidden basis of mental and physical life. Though mental and physical life may exist on a separate active or responsive level, exclusive of the movements of this deeper anatomy, their originary basis is often within the metaphysicality of the viscera.

The fibres

The entire frontal area of the body's midriff exudes fibre-like extensions. There are 279 individual types of these fibres. They are the most important aspect of this metaphysical anatomy in terms of the potential effects, and particularly damaging effects, that it may have between persons. These fibres exist within all persons, and an intention within the processes described here is to reverse the past effects of these fibres. They are expelled from where they may have entered the anatomy from others, and retrieved and fortified within one's own viscera.

The fibres are a centre of human force and reaction. They vary from a fine consistency that is like gossamer to a hard consistency that is literally like metal wire. They are temporal elongations of light that extend to varying lengths and in various directions. They shoot out of the midriff area in a Protean and instantaneous manner. These extents are limited but extend to lengths that wrap around within the encasement of other persons. Their impulsive force is not commonly felt or experienced, as impulse or as affect, but their effects are real and permanent. They are a main cause of distortions of the human body. And their strength of force is not necessarily related to the strength of physicality or psychical constitution of the person; any person can be intensely impulsive in this area.

There are described here 22 sets of these fibres, existing as specific types and consistencies, as shown on pages 58-61. These sets coincide with the internal and the encasement light, through their consistencies and colours. As with the internal substances, there are 14 colours of the internal fibres, including black, violet, blue, light green, dark green, red, orange, yellow, white, pink, grey, brown, clear, and silver. And as with the encasement, there are 15 colours of the encasement fibres, including grey, black, violet, blue, turquoise, forest green, pink, mars red, brown, silver, clear, copper, gold, white, and amber.

Types *a.* and *b.* listed below tend to extend from the upper midriff, while the rest extend from below the chest. All of the fibres extend from the midriff in multiple forms or masses, except for types *o.* - *r.*, which only extend from the centre of the gut as a singular form. The fibres have been given descriptive names here, as follows:

The internal light fibres include:

(a.) Gossamer & Gossamer plus silvery-clearness, (b.) Threads, (c.) Plumes, (d.) Velvet chords, (e.) Substance, (f.) Strings, (g.) Bright, saturated substance, (h.) Thin wires, (i.) Stems, (j.) Pipes, (k.) Condensed cylinders.

The encasement light fibres include:

(l.) Wires, (m.) Rugged lengths, (n.) Bars.

The singular internal light fibres include:

(o.) Stem, (p.) Massed wires with core, (q.) Central mass.

The singular encasement light fibres include:

(r.) Massed wires with core.

An exception exists to the full spectrum colour range of these fibres, involving nine casts of violet rays. They exist as violet, violet-red, and violet-blue casts, and include:

(s.) Rays, Rays plus clear, & Rays plus silver.

The consistencies of these fibres may be vaguely alligned with the substances of this anatomy; *a.* with the vaporous light, *b.* and *c.* with the colourness light, *e.* and *f.* with the substance light, *g.* with the light of the corporeal body, etc. The specific consistencies of each of the fibres are described in detail on pages 111-114.

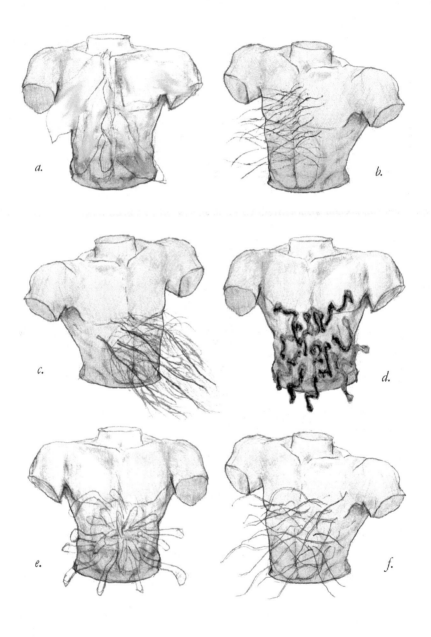

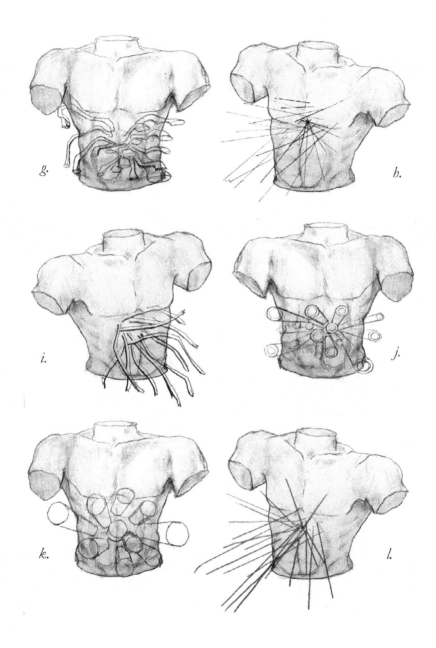

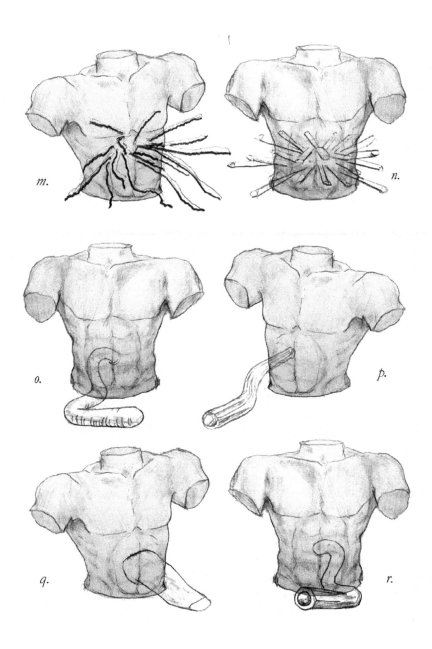

s.

The beams

A second type of extensions exists in a human being consisting of a ball-like area of energy, located centrally within the gut, with beams of light extending from it in all directions, spherically, as shown on page 62. They are taught, straight lines of light extending directly outward. The beams and the fibres are two separate entities and the one may be strong while the other is weak, and visa versa. These beams, which radiate from the interior of the gut, are a centre of bodily perception, and have an ability to create imagery in the imagination. They are a centre of dreams and *dreaming*, and are also the centre of human perception in general. They exist in all persons, alightened to some degree, where a main intention within the processes described here is to alighten these, and bring about an intentionality of these beams. They alight to a high degree in the practitioner, as a viable mechanism, associated here with the alchemical *lapis*. This alighting is an immediate but unnoticeable event that is permanent, and manifests as the ability to intentionally

effect ethereal energy, through their intentionality, movements, forces, or vibrations. They have the ability to have effect on any ethereal light that is coloured or has within itself a vibration. They cannot, however, have effect on physical matter directly or on energy as it is in itself. These forces are then enhanced and actuated through the breath and breathing techniques. The beams are utilised for the loosening and expulsion of undesirable energy, and for the retrieval of one's own energy, which is intimately connected to the breath. They alighten in whole extending radial areas through an intentionality, and are something like bendable poles, experienced when pressures of energy or resistances are contacted by them. They are potentially dissipative or penetrative forces allowing for intentional purification and alterations of coloured light.

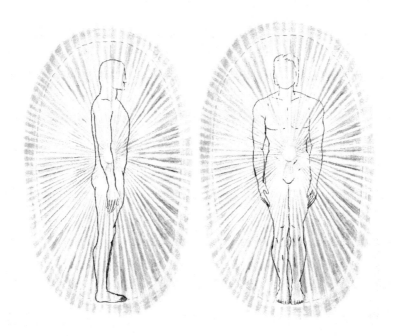

The gold square

There exists a thick square in front of the midriff, outside of and adjacent to the encasement, as shown. It appears as gold and contains nine layers of light. This includes a layer of white, grey, black, clear, violet, silver, copper, gold, and amber. It is an energy separate from the encasement that also decays by dissipating, or by accumulating on this same square area of others, or extending into others' anatomies. This energy is similar to the encasement light, though it has an intense consistency that is sticky or rubbery.

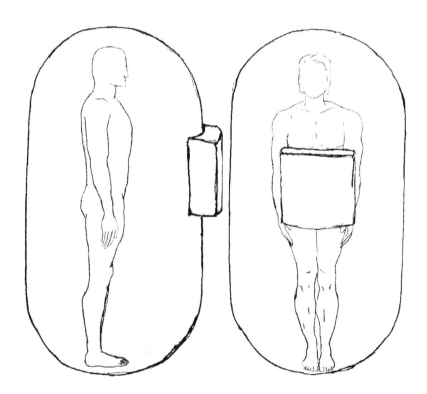

Decay of the fibres

The decay or fecundity of the phrenic area of this anatomy is a prime basis for the state of the anatomy as a whole, and therefore of the physical body and of one's well being. Though the light beams never decay all of the phrenic fibres will break off or disperse. This is based on their instantaneous generation and regeneration, wherein an essential fecundity is gradually diminished. These lengths collect at the sides and back of the encasement on one's own anatomy, or on the same area of others, if they are inaffective on the other's anatomy. They will either lay vertically along the outer rear of the encasement or take on a somewhat clustered formation, as shown. They remain in their original state, and the violet rays and silver central singular fibres also lay lengthwise, as shown by the rectangular shape and central mass.

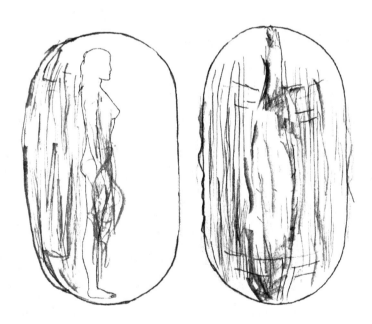

II
Purification and Renewal

But I live in my own light,

I drink back into myself the flames that break from me.

Friedrich Nietzsche, *Thus Spoke Zarathustra*,
'The Night Song.'

Visualisation and position

Purification and rebuilding are accomplished through a perspectival relation to one's past and to others, and through a visceral imagining of light and past experience.

Positioning of the anatomy

The act of purification and rebuilding is accomplished most proficiently while lying on one's back, with a few necessary exceptions. These procedures can also be done while standing or in any position, but lying down is the posture in which the body will sense everything that takes place, in a sensitive manner, while the physical functions of the body are in their most dormant state.

It is best to be covered with a blanket for comfort and moderate temperature. Heavy clothing or thick synthetic material should be avoided, and one should be away from large, operating machinery. The arms and hands should be away from the midriff area and away from the aural area surrounding the body, preferably on the chest, keeping them from interfering with the *phrenes* and vortices and the anatomy in general. The legs should be straightened and may be either apart or crossed. One should be comfortable and relaxed, alone in a quiet place, with time for concentration and silence, and without physical or attention drawing interruptions, because individual sets of energy movements can take unexpectedly long periods of time.

Imagination of light and the other

There are a number of ways to utilise memory and imagination for this praxis, including several optional ways of relating to others, or to memories of involvements with others. There are differing types of confrontation which consist of picturing oneself or others as a physical, corporeal body or picturing oneself or others as a light entity when engaging in purification and rebuilding. The choice of which method is used depends on the discretion and judgement of the practitioner, where these may be combined in various ways.

There are three types of imaginal confrontation:

1. Picturing oneself or the other as a light entity from where one is lying.

2. Picturing oneself or the other as a light entity while imagining being at the site of a past event.

3. Picturing oneself or the other as a corporeal body while imagining being at the site of a past event.

When reversing exchanges of light between oneself and another without returning to specific memories the other is either pictured as a light entity beside or in front of oneself from where one is lying, as shown:

These two positions are basic, though any positioning will suffice.

Retrieving light from within oneself is accomplished by picturing oneself as being a light entity surrounded by one's own light, from where one is lying or from wherever one may be at the time.

Returning to specific events in memory should always be done where an extensive exchange of energy occurred at a specific time. In these cases the other is pictured as a light entity or as a corporeal body while imagining being at the site of a past event.

In all cases of exchanges of light there is a real proximity to the other arrived at within the infinite spatiality of the light entity, where one's existing beams of light sense the other's presence, able to reverse exchanges of light as if its distances of movement are at close proximity. The other is conjured, so to speak, by remembering and feeling, and most importantly visualising; because this visuality contains a primacy of power to install this proximity. This visualisation need not be strongly projected within the physical space of where one is lying; what is important is that the image in the mind is felt viscerally, and that it connects with one's intentions and sensibilities, and with the extensionality of the light beams. This entity of one's own, of another, and in its detail, is brought into being, so to speak, and set, accessibly, within its infinity, through this intentionality.

Levels of ability

The methods described here assume the practitioner has attained full access to the ethers. This means that one has accomplished

dreaming and has successfully undergone the blackening or putrefaction through phases of the *opus*. These phases are described in chapter V. Otherwise, there are two prior levels to this purification praxis. The first level pertains to the practitioner who has not yet accomplished *dreaming*. At this level it is beneficial to simply return in memory to events and interactions from one's life and personal history, and enact the breathing techniques, which will be described. Doing this without utilising the peacock's egg will train the body and perception to change perspectives, and an unexchangeing of substances will occur though this may not be felt or experienced. These methods are described by Castaneda. The second level pertains to the practitioner who has accomplished *dreaming*. Experiences of *dreaming* will increase the effective nature of this purification. The methods described here may then be attempted successfully to some degree, though it is unlikely that major expulsions will be accomplished or that the fibres will be expelled. The abilities at these levels will also vary, depending on the person.

Acquiring a state of being

There is generally no requirement to reach a special state of being for the expulsion and retrieval of energy, provided one can relax and silence the mind. One of the intentions of this praxis however is to achieve a detachment and a serenity. There is a requirement within this process which has a complex interplay with one's states of being, such that the retrieval of light which was lost detrimentally requires that its original psychological tendency be reconstituted or overcome to some degree. This overcoming is also automatically accomplished to some extent by the expulsion of light prior to

retrievals, as this affective light is also the cause of the loss. A psychological tendency is often maintained within the anatomy by affective light that requires expulsion, though its affect is also normally a tendency which has a deeper basis in one's history. This history accumulates through repeated affects such that as this history is reversed while this process goes on everything becomes easier and an emotional freedom is gradually acquired. Once large quantities of energy are expelled an emotional strength develops beneficial for this praxis and for the control and distances required to maintain a strong psyche and anatomy. There is a kind of spiritual attainment that takes place then within this purification and rebuilding, in which the spirit is gradually refined, and wherein the expulsion of energy becomes freeing on deeper levels than would be reached through intentional alterations of mood.

The more massive affects that have permanent detrimental effects occur due to an impasse or an aporia of some kind, a moment or situation involving a loss or obstruction of path and psychical path. This is particularly the case with the insertions or mergings of others' phrenic fibres. Exchanges of energy occur within the fluid activities and reactivities of an alchemistry within this anatomy. But an impasse, often combined with a doubt or perplexity, gives rise to the soul's moments of vulnerability, which may or may not be consciously recognised at their time of occurrence. Consciousness will suppress or deny these moments of massive permanent affects when they occur, but which occur alchemically nevertheless, and wherein these moments may or may not have an afterward manifestation in consciousness. Generally, conscious defensive strengths and repressive strengths are developed against these moments in persons. Nietzsche's life affirmation and *amor*

fati include a countering of the doubts and detrimental affects brought about by the aporia. And much of Castaneda's practical advice has this quality. The flow of one's fatefulness or path encounters an impasse or disengagement, which renders its light vulnerable to detrimental affects. But consciousness is not always able to deter these affects, regardless of its states. And affects that become effective during these moments of doubt are temporal in nature, and their effective nature is not necessarily based in any reason that can be discerned. To discern psychological reasons for these effects can be of a complicated nature, and is not necessary to know or analyse. Often these moments or extensive effects arise in persons due to complexes. A complex within the psyche will arise causing a moment of aporia, that may be largely unfelt, but which allows for extensive effects to occur.

One's own taste and character will be involved in deciding the manner in which one returns to moments in one's history, or the methods used for the praxis in general. This further discussion is intended mainly to give some guidance to the initiate for the purposes of erasing exchanges which may have taken place in situations of intensive damage, or experiences of distress, or of victimisation. In some cases there will be a return to events involving confrontations with people who meant to do harm, situations of trauma, etc. These are the times of the most extensive damage, particularly to the phrenic area and encasement, and might require a strong stance in order to erase the effects of an event. As a rule one returns to these moments by simply visualising the appearances of the moment, and the anatomy, or peacock's egg, in the places of the persons involved. Most damage is caused by other's fibres entering one's own space and remaining there indefinitely, where

the substances are more a basis of one's constitution that becomes persuaded or impure. But the fibres, in their permanence, are always a basis of some kind of damage, and will exist in levels that have to be repeatedly fanned over and expelled until all of the forces are removed. In this way it can take several days to erase the effects of a single occurrence, but these experiences, which everyone has in their history, are the most important expulsions. For persons who have experienced difficult or serious trauma however, this simple returning may not be possible. And so some guidelines are given here.

Returning to one's past, particularly when returning in memory to unpleasant or damaging experiences, can be difficult and hard on one's normal well being. Eventually one learns to trust the light entity and not concern oneself with anything else, but in the beginning this may not be possible. For this reason it is important to strive to maintain some special equilibrium and sobriety while remembering past experience. One should strive for some objectivity, and not understand or feel oneself to be a victim or a victimiser. Retrieving and returning energy contains its own balancing effects that should be trusted to some extent. The intention is to be serene where the feelings being retrieved and returned are remembered and not felt. The deep and unconscious states that initiate the most detrimental exchanges of energy, their *deep sense* of doubt, exist on too deep a level to simply and easily remove them from one's being, but one's mood should oppose these states. And a confidence should be maintained, so that regardless of how hopeless things seem to be, or how impossible an erasure seems to be, this is only an illusion maintained by the mind. *The real problem is always within the anatomy.* Everything else

belongs to an interpretation; in fact, the interpretation that takes place in the mind changes as the peacock's egg changes. And with persistence and patience any situation can be balanced or inverted, particularly considering further results of this process.

What is sought is a strong state of being which opposes the states and emotions one had at the times of interaction. Lightness, humour, and a kind of aloofness are appropriate, but with focus and equilibrium, and kind of indifference; taking offences with an alchemical grain of salt, so to speak, and dissolving affects. One is also temporarily stepping outside of the boundaries of convention and obligation, where deep disagreement and disengagement are sometimes necessary, with a feeling of separation and the courage to invert decisions or intentions asserted on deep levels. There is a sense to which one is removing a being subjected. This is particularly the case with the expulsion of the fibres. The word 'subject' derives from the prefix 'sub' meaning below or beneath, as in 'substance,' and from 'ject' meaning to throw, as with 'inject' or 'reject,' as to subject means to *throw beneath*. The affects of others' energy is not always merely a joining and agreement, but is often an overpowering subjection that involves damage to this anatomy that may have never manifested in any conscious way. An indifference to others' persuasions is required, and an assertion of one's own force, as the exertion of a kind of sublime force; which is not physical or muscular, but arises from a serene mood, indomitable or immovable, with a steady obtrusiveness. Detachment is essential to this praxis, and when recalling one's past situations may be entered as if belonging to a dream or a film. One's position within the situation should be maintained as a difference from what was once experienced, where emotions are not re-experienced, the situation

is re-experienced in a different state. One returns to the event and examines the situation or self from a distance, allowing for access to the energy exchanged then.

The reassembling of an event takes place by itself to some degree, imagining the past from a relaxed position, being at ease. There will be momentary images not consciously remembered or seen, but recalled on a deep level, causing a more powerful returning to the event. There is a sense to which one is re-establishing oneself at the site of an event while the present context is forgotten, and there is a sense of real confrontation. From a position of being removed from one's present context, one can go anywhere in memory, with a here and now sense of experience, space and time. Other persons are then brought into appearance in memory, but wherein the light entity or peacock's egg is also imagined to some varying degree; which may be focused on with an almost entirely absent memory of the bodies and other physical presences within the event.

By expelling energy one is removing affective forces, and through this reconstitution of the psyche, correcting one's perspective within events, separating force from event. This purification is, in its essence, the dissipation of external or foreign forces that cause a pathos, or a doubt or necessitation, in their deep senses, or a necessity to decay, or to bleed, so to speak. In general, empathy, agreements, affects, and forces are removed, asserting a separation of light and energy from events. One is freeing the psyche from the coloured gradations of light which necessitate one's being. And then the outcome of a thorough purification will cause events and interactions to become something like the memory of a dream, or

of film or theatre, in which memories, whether desirable or undesirable, take a desirable place. In any case, a detachment is embodied wherein images are separated from their coinciding energy. Events are not lost or forgotten, but are sensed as having occurred within a space and time which is somehow dreamlike, where one's light exists within a separate temporality, infinite in its limitlessness and measurelessness, and which also exists eternally.

Force and breath

The initial activity of the practitioner used for the expulsion and retrieval of energy is breathing. Breathing techniques are essential to Eastern martial arts and its history, for reasons of health and strength, and to collect and store *ch'i*, psychic energy or life force. Breathing affects the physical body through the lungs and stomach, and through the body's blood, though, the breathing described here, as in martial arts, is not understood simply as air entering the lungs. And it is given less importance here than in martial arts, given this understanding of the light beams, where the breath is intrinsically attached to the light of the body through these light beams, that are not necessarily dependent on the breath.

In practise inhaling and exhaling is always done through the nose, and is never really deep or forceful breathing. It is intended to cause vibrations and movements within the beams, which it does through the midriff area, and which requires only subtle movements. It is possible to utilise the beams without using the breath, by attaching an intentionality and force, through the midriff area, to the beams as they may be directed at or against energy. Breathing

merely assists in causing vibrations within the beams, via the central area of the body, and is not the real force behind anything. But utilising the breath is the least strenuous and most effective method. It *always* must be done by fanning the head, regardless of what is taking place.

Generally, inhalations assist in the pulling and breaking up of energy, and exhalations assist in the pushing and breaking up of energy. This is not always the case however, and though inhalations normally assist with retrieval of energy and likewise exhalations with the expulsion of energy, in practice these have to be sensed through experience. Inhalations should generally be done while fanning the head right to left, since most retrieval will return to the right side of the body, and exhalations left to right. This fanning then also involves a simultaneous movement extending to within the centre of the gut and the light beams that fan out from there. This method seems to be the most natural for the body and may be maintained as invariable practice. And this breathing is always only involved in the initiation of what takes place, and in the dissipations of energy, and should stop following that loosening or breaking up of energy. Following this the energy will begin its own movements and return to its origin.

The central sphere or ball-like area where the beams meet in the gut enacts the forces of the dissipation and of the pulling and pushing of energy. Most movements of energy are felt or sensed within the midriff area regardless of where they are taking place. And though the dissipation or loosening is accomplished there is normally an exertion of pressure which has to be continuously made, however slight, which comes naturally through a feeling for

what is taking place. Sometimes this exertion of pressure has to be focused on and maintained with force, and at other times it will be slight and can be maintained with slight effort, or will be naturally accomplished while one is preoccupied or sleeping. Everything requires an artful and also natural feeling, combining visualisation, relaxed silence and intentions, breathing, and phrenic force and movement. It is always the case that energy which has been loosened through vibrations will tend to return to its origin, and that if it was affective light its past effects will tend to loosen and also return. This feeling of retrieval and expulsion is almost always a profound, physical, and often very heavy feeling of the movements of energy. If this is not experienced then either a lesser or early level of practice, or perhaps nothing, is being accomplished.

Reversal of affective light

All light expended from this anatomy is potentially affective, in itself and through its degree of force. These forces are determined by the nature of the light itself, and by the intentionalities and reactions of the psyche. Naturally, this affectivity becomes complex since chemical forces are acting with other chemical forces. This interaction is presented here theoretically, to present a foundation and broad picture, for understanding and to give the practitioner a basis to devise approaches and methods. It should also be noted that, despite the complexities of practice presented here, eventually one ends up doing mainly three major things: expelling masses of fibres from the anatomy, expelling masses of others' substances from the anatomy, and cleansing the body of foreign chemicals;

the remainder of the purification practice, including the retrievals of energy, follows easily, or becomes secondary.

Affective light in theory

Retrieval of one's own energy is often not possible without a prior expulsion, where a loss had been caused by an effectual light, maintaining the exchange as it stands. These expulsions involve instances where an affect had taken place with permanent effect within one's own anatomy, either from another person or by some chemical or radiation. Exchanges of light between persons involve a quadratic movement, which moves fluidly and chemically, but nevertheless contains four essential possibilities. While all energy that expends or extends from a person is potentially affective, it will be two of these four possible states within an exchange: reactive or intentional,[1] and then effective or ineffective. These are the four possibilities of movement within an exchange; which does not explain the occurrence that takes place momentarily within a psychology since on this level of energy the moment can be a complexity of these forces. It explains the activity of the light itself.

Expulsions then involve both others' effective energy and others' ineffective energy from within one's own anatomy, as this ineffective light accumulates within one's own reservoirs or on the encasement in the case of encasement light. And retrievals of one's own energy involves both that of one's own expended effective and ineffective light, as it accumulates within others' anatomies; both as effective light, existing within effected places within others' anatomies, or as ineffective light existing within others' reservoirs or on others' encasements in the case of encasement light.

All effective and ineffective energy then has a further distinction to be made. It either detaches from the originating person or it does not. If it does detach it will have a base-point within the receiver's anatomy, existing within an effected area of the anatomy, or within the spheres in the case of ineffective light. If it does not detach it will extend from a root point on the originator into the effected area of the other's anatomy, or will simply extend into others reservoirs or onto others' encasements in the case of ineffective light.

Detached energy has to be accessed at its base-point, and undetached energy may be accessed at any point prior to its contact, though it is most effective to access it at its root area within its originator's anatomy. These root areas are described in the following subsection, *Reversal in theory*. This issue of base-points only refers to substances and does not refer to the fibres. The fibres have broader base areas where they may be accessed, or, if they are undetached, they may be accessed at any point along their lengths prior to contact. The base-points are not special points within the light itself, they are points of attachment. And the spheres, though it may seem they would be of high importance, only house the base-points of detached ineffective substance energy exchanged between persons.

If expended ineffective energy is not exchanged between persons, and is simply one's own expended light, it will extend into one's own reservoirs or area surrounding one's own encasement in the case of encasement light or fibre light. It will never completely detach and so has no base-points to be concerned with.

Expended affective light may be imagined as a sphere that spins in either an intentional or a reactive direction from a certain state of being or structural constitution, as a collection of coloured light, with a certain force or speed. Intentional force then will tend to be more directed than dispersed, as energy is spun off, so to speak. Then when an exchange takes place the nature of light as effective or ineffective is decided by its own forces and by its recipient forces, similar to the complex ways in which chemicals may react to each other. These complexities are not important to know in practice, but may be theorised nevertheless. The forces of affective light are partly determined by the volitional or intentional force of the originator's light, and then by the light itself as it contains its own coloured and tonal forces which will be discussed in the following subsection, and in chapter III. And the volition of this light may originate as intentional or reactive energy. Then the forces of exchanged affective light are determined by these originating volition and intentionalities, and inherent forces, and by the same forces of their recipient light or structure. Exchanges of light then occur in a complex and fluid manner through degrees of forces.

The chemical and forceful nature of these expenditures and exchanges, as analysed here, refers only to the metaphysical anatomy, and carries no further implications, per se. The definitions given here do not refer to a being affective, intentional, reactive, or effective in any psychological or physical sense, and are a way of talking only on the level of this metaphysical anatomy. This level has its own constitution, forces, activities, and vulnerabilities, that are only partially determined by or constitutive of conscious or felt experience, which will also vary depending on the person or

state of the person. Felt and conscious experience is a different matter, which is related to these, but on a less immediate level.

Reversal in theory

Most often exchanges of energy between persons will take place in a complex way, and it is possible, and at times advisable, to simply enact the breathing techniques without focusing on specific movements and areas, so that a general reversal of energy takes place. In this way expulsion and retrieval may be accomplished simultaneously. And simultaneous expulsion and retrieval is always an advisable possibility in practice, regardless of the method of reversal being utilised. The specific descriptions given here, however, involve accomplishing expulsion and retrieval in specific and systematic ways, so that energy is clearly followed. Then if expulsions and retrievals are done separately energy flows in one direction, allowing reversals to be done in an ordered manner. And the most difficult of these techniques involves the expulsion of energy which is or has been permanently effective within one's own anatomy, while all of the other reversals of exchanges will follow or flow more easily.

When reversing expended light one accesses and vibrates the energy at a specific point or area. Following this it will always reverse its direction and expel. The rules regarding these base-points and areas are summarised as follows:

The detached effective fibres may be expelled by accessing any point along them near their area of effect, and the undetached fibres may be accessed at any point between their area of effect

and their place of origin, preferably at their origin. The fibres either enter the anatomy crosswise or at some angle, or they lay within the body or along the encasement; repelled, ineffective, or effected fibres always laying vertically at the rear-half of the encasement.

The effective substances require either access to their base-point, which will be anywhere within the anatomy, or if the energy is not detached from its origin, access to the substance at the extension point from its origin.

Base-points that exist within the spheres are not attached to effective light, but rather to repelled, ineffective, or effected light. And lost energy that remains within one's own anatomy does not have a base-point but merely extends from its origin.

Detached and exchanged ineffective energy is accessed by the spheres and the fibres accumulated at the back and sides of the encasement. Any of these collections of light may be fanned over using any method of imaginal confrontation, sensing their colours, consistencies, and positions correctly, forcing releases from the anatomy. Following a fanning over the spheres energy will flow quickly and return to its source. One's own ineffective energy may be retrieved from others in these ways, while others' energy of this kind may be returned in these ways. Other persons' energy contains nothing beneficial. There is a weight to others' ineffective energy within the reservoirs and encasement that will keep one from attaining one's goal of balanced purity and equilibrium; though an exception to this exists in the case of the amber light.

Detached effective energy is expelled by accessing all of the possible effected areas of the anatomy, including the vortices, cylinders, the

entire corporeal body, the entirety of the encasement layers, the frontal quarter spheres and cylinders, and the gold square. Purifying the vortices tends toward internal strengthening, purifying the cylinders tends toward an internal tightening or centring, purifying the corporeal body tends toward physical cleansing, purifying the encasement tends toward physical structural strength, purifying the frontal quarter spheres and cylinders, and the gold square tends to increase a detachment. Expulsion of the substances tends to better one's general constitution, and expulsion of the fibres tends to better one's form. These are only generalisations however, as purifying any of these areas tends toward an overall reconstitution and health that extends to all of these changes to some degree, which is always a relief from, or release of, detrimental forces.

Undetached effective energy is expelled by accessing the place or area of its initial expenditure. It is light that expended from one person to another, having entered the other's anatomy, having a permanent place and effect there, but which has remained attached to its origin. This attachment to an origin can be permanent and last a lifetime. There are five of these areas that each expend or extend separate types of energy, including: the entire area just in front of the body and midriff extending from the top of the head to the genitals, the head, the entire physical body, the encasement, and the gold square.

These areas, as base-points of effective light, are important to know and focus on. This is because undetached energy that exists within one's own anatomy, as effective light, can only be expelled as such. The area in front of the midriff expends all substance, encasement, and fibre light, and should be fanned over in its entirety. It should

be fanned over for each colour as substance colour, as colourness light, as vaporous light, and as encasement light. The fibres always expend from in front of the midriff, as already discussed. The head expends all of the types of colourness light, and should be fanned over as a solid area, including the area in front of the head. This energy can also form into something like a hardened fibre. The entire physical body, including the head, expends the bright light of the corporeal body, and should be fanned over in its entirety for each colour. This will initiate expulsions of large masses of this rugged feeling energy from one's own body. The encasement expends its encasement light and should be fanned over as a whole solid shell while imagining its colours. This is done for both the inner, hardened layers and the outer layers. And the gold square expends its own light and should be fanned over as a solid mass while imagining its colours. These areas of other persons are all fanned over, imagining their respective colours and consistencies of light. Following this the energy will pull out of one's own anatomy readily and easily, and this, as well as all other expulsions, will be followed by natural intakes of energy.

It is also important practice to fan over the external fragment area for any expulsions in a general way, as if energy is based there, because all undetached effective energy will not be accessed through memory of persons. Energy exchanged with others may also always be sensed within a single, abstract entity, which may be imagined for reversals of exchanges in a general way. Others' light and one's own light entity are always, from a certain standpoint, single abstractions which alight in degrees, and in terms of individuals that are sensed or remembered. The reversal of exchanges between selected individuals should always be maintained in practice,

particularly where there exists a sense of detrimental overpowering. But sensing exchanged and effective energy in this abstract way is a possibility and option, as exchanges and affects will not always be accessed or clearly determined through other methods. Positioning of the others' light entity, when not returning to specific events, may be done from any perspective, and may be viewed from the front and back to access all of the areas. Eventually these become natural to sense and understand, and all that is required is the slightest touching of memories to initiate flows of energy.

Expulsion of effective light

Human light effects this anatomy by entering it and having a permanent place within it. This effect remains there, to some degree, whether it originated in early childhood or in recent situations. Expulsion of this energy may be accomplished in a thorough way by utilising the tables shown on pages 102-106.

Expulsion is accomplished either by focusing on the base-point of effective energy, or by focusing on its source point, both of which might then involve energy that extends to anywhere else within the anatomy. The base-points of insertion may be anywhere within one's own anatomy, and the source points are always on others' anatomies, as already described. Any of the various types of human energy may be based in any part of the anatomy. So, for example, encasement light will enter and base itself in the physical body's light, or *visa versa*.

These differing areas of the anatomy may be thought of as differing in their levels of existence. Effective energy does not travel through

the encasement into the vortices and body to base itself there, exactly. The vortices, corporeal body, and encasement are on separate levels in their vulnerability to effects. And these differing levels may be treated separately when expelling energy.

In the beginning, when one first learns to expel light, the processes may be slow and difficult. There is then, at this beginning level, a series of stages involved in expelling a mass of energy. Following the breathing that loosens the energy it manifests as a pressure against the light beams. This can take place anywhere within the anatomy, and the pressure may be slight or heavy. Then a kind of kneading is done with the beams, against the mass, or a sustained pressure is applied to it, until it begins to dissipate. This kneading can also involve a drawing out of energy from where it is deeply set, especially from deep within the midriff area or spinal column. This is followed by a guiding and pushing of the energy so that it moves out. Upheavals at this early level of practice can be tiresome and lengthy, and should be worked through unemotionally. With time they become less strenuous on the body, and this kind of slowness or difficulty ceases to occur. The masses, however, in their massive quantities, do not diminish in the later stages. Very often energy is literally pumped out for long periods of time, sometimes well over an hour for a single mass of energy.

Expulsions and upheavals are usually followed immediately by intakes of energy, and extensive expulsions are most often followed by extensive and massive intakes. If there are various types of energy involved these intakes occur in some order and will generally take a much longer time than the expulsions. They can also be delayed, it seems, and occur up to the next day. These intakes often begin

from within one's own encasement, though often it is as if energy sits against the outside of the encasement and waits to be taken in, usually from the right side. They can originate from any area surrounding the body or encasement. Light will return onto the encasement, or into it, or into the midriff area, or into any area of the vortices or body. Sometimes these intakes are very large and forceful, and may rest within the encasement before entering the vortices. They can also be experienced as massive solidities, and feel literally like quantities of heavy liquid or even masses of sand pouring into the body. And large intakes of energy, though strengthening the body, may cause temporary fatigue and need for rest.

Nothing should be forced too hard, as energy will always move in its appropriate direction naturally. It should be allowed to flow in its own direction, though often it has to be somewhat guided and controlled. The energy can have an active, forceful behaviour during large upheavals. If it is not guided out correctly in relation to its force, energy can rise up into or around the upper half of the body uncomfortably, for example. At these early levels of development energy will at times manifest as a hardened mass, which requires a kind of scraping away; or a mass may seem difficult, as if like a ball or marble that moves sideways under a cloth when pushed down on, if it is not pushed directly in its centre. As the expulsions goes on, however, energy will flow out easily and readily, requiring only a slight guiding pressure.

Expulsions will develop their own initiations. Upheavals of large quantities of energy take place, seemingly on their own. These upheavals will often manifest as a pressure in or around the midriff,

and they may be accompanied by undesirable feelings and moods. These unintended upheavals are often human substances or fibre energy, but they are sometimes not human energy. And there will be extensive series of these from the vortices of some of the internal organs, which will be discussed. Unintended upheavals, which seem to rise up and wait for pushing out, should be followed through and attended to prior to intended expulsions. At times these unintended upheavals will expel by themselves and at other times they will require an initiating breath or force. During this process, in the depths of it, undesirable feelings, emotions, or states will manifest that are often caused by upheavals taking place, often of the fibres, that may be located and fanned over, by sensing the place and form of their pressure. These occur because the body is going through a natural reversion that acquires its own momentum, and as what may have once been digested by a strong or healthy spirit here re-manifests as inflammatory. These upheavals will even manifest in dreams that accompany these pressures or movements of light. And pressures are felt in the most sensitive ways while lying down, where other physical positions deter much of the ability to sense pressures and lacks. An important priority involves attending to these pressures and lacks felt by the body. It is important then to recognise these forces, which has to be learned in practice, but which becomes a natural sensibility.

One has to devise one's own methods and procedures. The methods prescribed here are intended as a basic system, which may be followed loosely or strictly. It is possible to take this rebuilding praxis very seriously, even by being celibate and involved with martial arts or meditation, or other breathing techniques to circulate energy within the body. Once the body becomes used to doing the work

hours a day may be spent on it intensively. Generally, one's methods should be understood in terms of individual sessions, in which an expulsion is done followed by a natural intake. The intake usually takes much more time than the expulsion, but which also requires less or no attention, and will occur during any activity or during sleep. Then once the intake has completed a retrieval or another expulsion may be done.

In the beginning the body may be fanned over without focussing on its vortices and levels, but after these abilities are acquired the cylinders, vortices, corporeal body, and encasement should be fanned over separately, with separate breaths, focusing on separate individual areas of these. Expelling one type of energy from the entire anatomy can require up to 100 or more exhalations, depending on how thorough one intends to be.

The four mnemonic aspects of these methods: event, person, feeling, and colour, are interchangeable and combinable in many ways. Emphasis on one seems to require less of the other three, though colour alone, without at least some general sense of its human nature, will tend to cancel the effect. Then combining these four aspects causes a more focused access to the energy. And something similar applies to the energy itself; combining colour, form, consistency, and precise place of the light allows for the most certain access.

In the beginning individual persons should be focused on while expelling a single type of human energy. But as these expulsions go on, a day comes when very large upheavals occur by focusing on a single colour or type of energy without reference to any

particular person or place, seemingly expelling everything left of that energy type or cast. At this point no individual person need necessarily be focused on and light may be expelled by colour and type alone. This is when noticeable changes start to occur in the body. The physical and psychological results of expelling these masses are considerable. The results are not only psychologically freeing and strengthening, but will also be physically altering. This more massive expulsion then, through the alchemical *opus*, involves a slow, personal, and mysterious death of a kind, in which the forces of one's personal history no longer have effect. This spiritual change, associated with the alchemical death, is discussed in chapter V.

A seven step beginning method for expelling energy follows. It is advisable to begin with the substances, as the fibres can be more difficult, and require experience. The colours referred to here are described in detail on pages 107-114.

1. Focus on the other person or event, with the mind and the central area of the body.

2. Think of and imagine the colour in its specific tonality and consistency, with the mind and with the body. The colour must be imagined for each of the exhalations as being within the area of focus.

3. Exhale, fanning the head from left to right, as many times as is needed, focusing across the width of the body or the encasement, or whichever area is chosen for the expulsion. The encasement may be fanned over starting from the lower front, going up and over the encasement to the bottom again. At least eight exhalations are usually required to cover all areas of

it. If the body or an area of the body is being expelled from its specific area and level should be focused on and fanned over. The entire physical body may be fanned over with four or five exhalations, or once by focusing on a specific area of it.

4. The exhalation should be done while noticing the existence and weight of the energy being expelled. A slight resistance may be detected where the energy exists. This resistance or pressure is a part of what allows one to ascertain the energy's existence. And exhalations may be repeated fanning across areas where pressure is felt.

5. Repeat steps 2, 3, and 4 if expelling more that one colour or tonality.

6. A short length of time may be required for the energy to loosen. It will manifest as a pressure that may require a pushing effort against it, by kneading it or simply applying pressure with the light beams. This might also include a drawing-out pushing force. The light beams are pushed on it, controlled within the gut, until the energy dissipates and flows out.

7. The energy will begin to expel naturally, and from here continuous help may be required to push or guide it out, requiring focus and concentration at times. In the beginning, it will not be often that one may simply relax and allow the energy to flow out, because it will expel in an awkward way, seemingly pulling on areas, or remaining trapped in places. But all of the various consistencies of energy that have been dissipated will arise or loosen, from all areas within the encasement or body they rest in. Substances manifest naturally in some order, and may exit through any area of the body and encasement. Energy will generally exit through the area it was based in. It usually manifests as an expansion of itself from wherever it was lodged, creating what seems to be a much larger quantity than might

be expected. It will manifest as its consistency, which can be felt during the expulsion, being from a hardness to a liquidy vaporousness. Attention to the expulsion should then be continued until it ends; which it always will. And with time these expulsions take place in quick, direct, and easily flowing ways, that only require slight attention and guidance.

There are other techniques that may be used, particularly since in the beginning complications may occur. It is possible to fan the head at an angle while breathing, to loosen the energy from a vertical direction. It may also be helpful to fan with the hands or feet, across areas, but this is rarely needed and is only a device used to help focus the light beams. Sometimes masses of energy can be uncomfortably large, and can feel dangerously heavy or forceful, and can move around within the encasement. This can even be painful in areas such as the head, and requires patience and persistence in dissipating it. And in unusual cases it will also sit and not exit the encasement. Showering with hot water will soften the energy and cause the expulsion to flow easily. And it is generally beneficial to initiate expulsions while showering with hot water, or in some similar environment. This will generally cause the expulsion to flow well and to be more expedient. In the beginning however, it is important to be lying down and to remain in one position for the whole expulsion. A natural feeling will allow one to discern what is taking place and what to do, and experience will enable one to decide on these methods.

The kneading, pushing, and pumping of energy is usually not necessary, but this is not a physical movement of the body. The abdominal muscles will move, but this is centred in the movements of a mechanism that emerges in the gut.

A transition takes place at the completion of the expulsion of a mass, from the expelling to an intaking. This transition is often difficult to detect. The change in flow is sometimes obvious and sometimes not. It is generally immediately following, or even prior to the expulsion, as the intaking will sometimes cross over the expulsion. And the consistency of the energy is usually the same as the expelled energy, making it difficult to differentiate. If there is a question it should be assumed that energy is still expelling, and this will often be the case. With careful attention the change of flow may be detected, and one acquires an ability to discern this. Expulsions are usually experienced as a pushing, often sensed in the gut and often in the centre of the throat, and intakes are experienced as a general resistance against one's force that replenishes and flows more easily, and in a wider mass. The expulsions also give one the sense that they require attention, while the intakes give one a sense of fortification that does not require an exertion of pressure. The intakes are usually strongest immediately following expulsions, and gradually subside, and will often come in separate sets. And it is best to be lying down when they begin, during their initial rush, after which they will flow easily while the body is active or sleeping. Further intentional retrievals or expulsions should then be done only after these end or taper off.

Retrieval of effective light

One's internal light collects within others' anatomies as effective light, as energy which has had an effect, and often a permanent effect, on others' anatomies. Just as this may be expelled from

one's own anatomy this energy also requires retrieving from others. This is accomplished by procedures which are simply the reverse of the expulsion of effective light from one's own anatomy. This may include all internal and encasement colours, and may be retrieved in mass combinations. This energy will tend to return to oneself readily and easily. It should be imagined as being within others' vortices, cylinders, and bodies, or on the surface or within the layers of others' encasements, similar to the places of expulsion. And then one may fan over the originating source points on oneself to retrieve undetached energy. These retrievals require imagining the other, using one of the positioning methods or by returning in memory to past events, utilising any colour procedures as described. The breathing and loosening techniques are enacted and the energy will be felt flowing back into oneself.

Expulsion of the fibres

An important and difficult issue concerning the fibres, and this anatomy as a whole, is the potentially effective and permanent damaging nature of the fibres. These effects are reversed as these fibres are expelled from the anatomy.

The fibres can exist, as effective energy, within the body and encasement, and extend into and throughout anywhere within the anatomy. They tend to enter the frontal area of the anatomy, but they will enter from any surrounding area. Detached fibres will have a base area anywhere within the anatomy, and undetached fibres are accessed by the frontal midriff area of the person of their origin, or at some point prior to contact, as already stated. These rules regarding base areas are not as strictly true with the

fibres as with the substances, because there is generally an area of length that may be vibrated or loosened.

The effects of others' fibres on this anatomy is the type of exchange of human energy that is the most psychologically and physically effective, and detrimental. There will be moments in one's life when masses of these fibres will have had effect, as something permanent from that point in time onward. And the extent and quantity of these insertions should not be underestimated. There will exist multiple layers of their masses, involving all 279 types fibres, that had their effect within only a few moments in time. On average a person will have anywhere from 30 to 200 or more layered occurrences like this in their life, depending on the person, and on their age of course, each occurrence involving up to five or six layers of the complete set of fibres. Generally, these moments are not difficult to locate, as they stand out in memory, through their individual importance will often be clouded. This quantity will be furthered by other, more common moments, of emotional involvements, or sexual involvements, but these are not generally extensive, damaging occurrences, unless they involved a distress or something similar. And the results of removing these layers are profound.

The fibres generally enter the encasement and body at some horizontal angle, but will also exist vertically anywhere within the anatomy. They also fan out over the encasement, and wrap around the encasement.

The fibres are expelled from the entire anatomy just as the substances are. They may be expelled by colour and type in this

way. The difference in practice is that their various directions should be focussed on, and the area surrounding the entire body is fanned over because of their lengths. The area surrounding the encasement is also given special attention.

They should be focused on as each of their colours and types by fanning and exhaling while imagining them as entering the anatomy, either near or within one's anatomy, or near the midriff of the originating person, imagining them extending into the anatomy. Vibrations made along them and against their extensions in this way will cause them to pull out of the anatomy by themselves, usually immediately.

Fibres which entered the midriff will often extend into the head and above it, and those which entered the head or neck might extend downward into the midriff. Others' fibres will literally unwind themselves from within the body and expel. They can exist as solid forces and in massive bundles, and can wind around into small areas, or in large circular forms within the encasement. The fibres never exit the encasement once they have entered it, and will always curl or turn inward as their lengths extend.

Others' fibres may be expelled by using any of the confrontation methods already described. Undetached fibres should be expelled by imagining them as extending from within the midriff area of others' bodies, recalling the site of an interaction, or imagining the other person's anatomy in front of oneself from where one is. Generally, the area just in front of the midriff of the other person is fanned over, vibrating the fibres at their root, though this fanning may also be directed further outward and external to the gold square

area. All of the fibres extend from the midriff below the sternum, except for the thread-like fibres and the gossamer-like fibres that tend to extend from the upper midriff and neck area.

All of the single, central fibres will always extend from the centre of the gut as singular force. There is always only one of these of any particular type and colour at a single instant, where all of the other fibres will extend as multiple forms in a single instance. They do, however, conglomerate into a single mass, that directs itself in a singular manner. These singular conglomerations may be imagined simply as force but generally have a dark silver quality. They are perhaps the most important expulsions to perform, and may be pushed against or broken near their root. They cause the most damage to the body, and can also cause something like holes in the encasement, and may be expelled by loosening them from where they stand just outside of the encasement. Loosening a large number of these, which takes only a few minutes, may be followed by several days of expulsions; which can also stop intermittently for intakes, and then continue on.

The length of the effective fibres within the body can vary but is generally long, requiring time to expel. They curl around and lay within the encasement, and generally one can expect long, drawn-out expulsions lasting ten to twenty minutes or more. And if masses of fibres are loosened at one time these will often expel in series that can, on occasion, take 24 hours or more. It is difficult to estimate their maximum lengths, but it feels like they move at around three to six inches per second, on average. The wire-like fibres are the most incredible to experience. They feel literally like long, hard wires that pull out of the anatomy in curved lines. The large singular

type roll out in long, continuous forms, and may actually be felt tickling the roof of the mouth or the tongue as they pull out sideways from the head. They are the most forcefully potent fibres, and can cause deformation of the anatomy or a constriction that is relieved through their expulsion.

The central silver forces are intense, experienced as heavy forces against the body. The central stem-like fibres almost have an organic nature, and can pull out in an intense and severe manner. Some of the central substance fibres can feel something like a long piece of rubber being pulled out of the body. These feelings seem to be particularly the case when fibres expel from the physical body. The denser and courser fibres can then be slightly painful, and feel something like rough glue being extracted from the body's tissues. The bright, saturated substance fibres can be difficult, as an agitated expulsion, and can pull out from the physical body in a slow, rough manner. Hardened fibres that will have burned, so to speak, into the anatomy instantaneously and in an unfelt manner, will sometimes pull out in a slow and difficult manner. What have been called plumes here can also be slow and difficult; they feel literally as if stiff bird feathers are being extracted from the body and from within layers of the encasement. The pain, however, that sometimes accompanies the fibre expulsions is never serious or severe. And in unusual cases the expulsions can be lengthy and difficult. The wire-like fibres can be long and drawn-out, as a slow, but usually smooth expulsion. There will be cases when the intakes which follow the fibre expulsions will also be slightly painful, in a different way however, because the bones and muscles will on occasion intake intense quantities. All of the fibre expulsions including these difficult movements are generally a relief however,

to the anatomy and physical body, and are always followed by intakes of energy and natural repairs.

The fibres also initiate their own expulsions. They will manifest periodically as pressures in front of the midriff, or as agitations within the body or midriff, or as pressures or a heaviness on the encasement or surrounding oneself, and may be expelled from that feeling by fanning over the area of pressure. It is beneficial to imagine their colours or consistencies at that time, though simply fanning over the area will initiate their movement. Fibres will also seemingly initiate these expulsions mysteriously during sleep, often through an abdominal manifestation, through these may be delayed from a prior loosening. In terms of human energy, there is always at least some slight moment of recognition prior to an upheaval of energy, even if this occurs only in feeling or occurs in dreams.

Most damage to this anatomy occurs at specific moments in one's life in which layers of others fibres enter the anatomy during a very short time. There are always important moments one will remember that stand out naturally, and which will involve at least one full set of all of the 279 types of fibres within each of those moments or times. These events have to be gone over repeatedly by fanning over the frontal midriff area of the other person in memory of the event. If there is a particular moment in which a heavy or massive exchange occurred the event should be returned to repeatedly until all the energy is expelled, because insertions of the fibres can exist in momentary, temporal layers that will manifest naturally in some order through these returns.

The best procedures to utilise for expelling the fibres involve either focusing on others' undetached fibres for a single moment or person for all 279 types of fibres, or focusing on a single type and colour of fibre for the whole anatomy at once. Any combination of type, colour, consistency, person, moment, etc., may be utilised or emphasised, however. These effective fibres can also be sensed without imagining their appearances.

The moments in one's life when massive effects of the fibres occurred are the most important moments to recall, and are the times of the most extensive damage. These may have involved physical aggression, or may have been initiated very subtly, sometimes by a simple smile.

Use of the colours

All light of the peacock's egg is coloured and has specific casts and consistencies. (The clear light is referred to here as a colour.) These colours, tonalities, densities, and textures are acquired at the moment of the psyche's affective forces, and remain in their original states permanently, unless they are dissipated, or there is physical death. This loosening is accomplished in a most clear and effective way by imagining these colours and their formative qualities correctly whilst performing these reversals.

There are a total of 348 colours of internal light and 17 colours of external light; this being a total of 365 colours. Though this may

not be an exact number, considering the fluidity of this energy, it is an estimation that encompasses and accesses all of the possible human energy. It may be associated with the days of the calendar year and their coloured seasons, and with the colours of the peacock's tail, in its silver, mercurial mixtures. And to these are added the 14 brilliant colours of the physical body.

There are 15 types of fibres related to the internal light, and 4 types of fibres related to the encasement light. Then there are 3 types of violet rays. This gives a total of 279 possible fibrous emanations, when these are multiplied by their possible colours. This selection, when utilised through visualisation, encompasses every various possibility.

All of the colours of the peacock's egg, the corporeal body, and all of the types of fibres are listed and arranged in the following tables:

The light tables

Internal Light 1

	Black	Violet	Blue	Light Green	Dark Green	Red	Orange	Yellow	White	Pink	Grey	Brown	Clear	Silver
Colour														
Colour plus clear													■	
Colour plus crystallised clear													■	□
Deep colour													■	
Colour's brown tonality												■	■	
Shaded colour	■										■		■	
Colour's yellow tint							■						■	
Colour's white tint									■				■	
Clear plus colour's tonality													■	
Black plus colour's tonality	■								■				■	
White plus colour's tonality	■								■				■	
Grey plus colour's tonality											■		■	
Brown plus colour's tonality												■	■	
Crystallised colour														
Crystallised clear plus colour													■	
Vaporous colour														■
Vaporous-clear plus colour													■	

Internal Light 1 (cont.)

	Black	Violet	Blue	Light Green	Dark Green	Red	Orange	Yellow	White	Pink	Grey	Brown	Clear	Silver
Blackness plus colourness	■								■				■	■
Whiteness plus colourness	■								■				■	■
Greyness plus colourness											■		■	■
Clearness plus colourness													■	■
Silver plus colour														■
Colour plus silver														■
Silverness plus colourness														■
Colourness plus silverness														■

Internal Light 2

	Black	Violet	Blue	Light Green	Dark Green	Red	Orange	Yellow	White	Pink	Grey	Brown	Clear	Silver
Colourness														
Deep colourness	■	■	■	■	■		■	■	■	■	■	■	■	■
Colourness brown tonality	■	■	■	■	■		■	■	■	■	■	■	■	■
Shaded colourness	■	■	■	■	■		■	■	■	■	■	■	■	■
Colourness' yellow tint	■	■	■	■	■		■	■	■	■	■	■	■	■
Colourness' white tint	■	■	■	■	■		■	■	■	■	■	■	■	■
Crystallised colourness	■	■	■	■	■		■	■	■	■	■	■	■	■
Vaporous colourness														■

Internal Light 2 (cont.)

	Black	Violet	Blue	Light Green	Dark Green	Red	Orange	Yellow	White	Pink	Grey	Brown	Clear	Silver
Silverness plus colourness														
Clearness plus colourness														
Whiteness plus colourness														
Blackness plus colourness														
Greyness plus colourness														
Colourness plus clear														
Colourness plus crystal-lised clear														
Colourness plus vaporous														
Colourness plus silvery clear														

Encasement light (cool)

Dark air of the interior	Grey		Black		Violet		Turquoise		Forest Green		Cobalt Blue	
	Inner/	Outer	Inner/	Outer	Inner/	Outer	Inner/	Outer	Inner/	Outer	Inner/	Outer

Encasement light (warm)

Mars Red		Brown		Pink		Silver		Copper		Clear		Gold		White		White Metallic Glow
Inner/	Outer	Inner/	Outer	Inner/	Outer	Inner/	Outer	Inner/	Outer	Inner/	Outer	Inner/	Outer	Inner/	Outer	

Amber	
Inner/	Outer

Light of the Body

	Black	Violet	Blue	Light Green	Dark Green	Red	Orange	Yellow	White	Pink	Grey	Brown	Clear	Silver
Bright colour														

Light of the Gold Square

	White	Grey	Black	Clear	Violet	Silver	Copper	Gold	Amber
Colour									

Internal Light Fibres

	Black	Violet	Blue	Light Green	Dark Green	Red	Orange	Yellow	White	Pink	Grey	Brown	Clear	Silver
Gossamer														
Gossamer plus silvery-clearness														
Threads														
Plumes														
Velvet chords														
Substance														
Strings														
Bright saturated substance														
Thin wires														
Stems														
Pipes														
Condensed cylinders														

Encasement Light Fibres

	Grey	Black	Violet	Turquoise	Forest Green	Cobalt Blue	Mars Red	Brown	Pink	Silver	Copper	Clear	Gold	White	Amber
Wires															
Rugged lengths															
Bars															

Singular Internal Light Fibres

	Black	Violet	Blue	Light Green	Dark Green	Red	Orange	Yellow	White	Pink	Grey	Brown	Clear	Silver
Stem														
Massed wires with core														
Central mass														

Singular Encasement Light Fibres

	Grey	Black	Violet	Turquoise	Forest Green	Cobalt Blue	Mars Red	Brown	Pink	Silver	Copper	Clear	Gold	White	Amber
Massed wires with core															

Violet Rays

	Violet	Violet-red	Violet-blue
Rays			
Rays plus clear			
Rays plus silver			

Imagination of the colours

The colours of light are imagined as one would normally imagine a colour in the mind, but also imagined within one's intentions, so to speak, and imagined within the space one is directing one's intentions toward. Access to coloured light is accomplished through the psyche and its visceral nature as it enters a coloured mode, while imagining these colours in the mind is merely as aspect of this imagination. Some of the colours should be imagined as 'tinted' where there is an even mixture of two colours, and some as 'tainted'[2] where a dominant colour has an attachment of a lesser, merged light. It is always only necessary to imagine the colour as a single colour or, if there are two colours, as the mixture of these. It is important to imagine the colours as closely as possible to their description but the body also possesses a natural feeling for them and knowledge of their existence. And though in themselves they may actually be luminous, access to them is gained by visualising them as basic coloured substances, disregarding any luminosity, unless specified here.

The following are descriptions of the casts and consistencies of the energy listed in the light tables.

Internal Light 1

Colour refers to the colour itself with no mixture, as the light is in its basic or spectral state. It is the basic substantial state of the colour and is imagined and sensed as a substance like semi-thick paint.

Colour plus clear is the colour tainted with the clear substance.

Colour plus crystallised clear is the colour tainted with the crystallised clear light.

Deep colours are a heavy and substantial light, where some colours also darken.

Colour's brown tonality is the colour tinted brown.

Shaded colour is the colour tinted as it would appear if a shadow were cast on it.

Colour's yellow tint is the colour tinted with a yellow, except in the case of the purple, which is tainted. It is a yellow heightening or intensification of feeling.

Colour's white tint is the colour tinted with a white, as a pale tonality.

Clear plus colour's tonality is the clear substance tainted with the colour.

Black plus colour's tonality is the black substance tainted with the colour.

White plus colour's tonality is the white substance tainted with the colour.

Grey plus colour's tonality is the grey substance tainted with the colour.

Brown plus colour's tonality is the brown substance tainted with the colour.

Crystallised colour is the colour in a crystallised or hardened state, sometimes as a deepened tonality.

Crystallised clear plus colour is the crystallised clear light tainted with the colour.

Vaporous colour is the colour in vaporous and slightly airy state.

Vaporous clear plus colour is the vaporous clear light tainted with the vaporous light of the colour.

Blackness plus colourness is the blackness tainted with the colourness.

Whiteness plus colourness is the whiteness tainted with the colourness.

Greyness plus colourness is the greyness tainted with the colourness.

Clearness plus colourness is the clearness tainted with the colourness.

Silver plus colour is the heavy silver substance tainted with the colour.

Colour plus silver is the colour tainted with the silver substance.

Silverness plus colourness is the silverness light tainted with the colourness.

Colourness plus silverness is the colourness tainted with the silverness.

Internal Light 2

Colourness refers to the colour in its insubstantial state. It is imagined and sensed as insubstantial and dry, except that the clearness is like a thin, oily substance.

The gradations of the colourness redness are as described of the substantial light, but as a dry insubstantiality.

The silverness, clearness, blackness, whiteness, and greyness plus the redness are light tinted with a redness, differentiating them from the tainted gradations listed in Internal Light 1.

Vaporous colourness is the dry insubstantial colour in a vaporous state.

Colourness plus clear is the insubstantial colour tainted with the clear light.

Colourness plus crystallised clear is the insubstantial colour tainted with the crystallised clear light.

Colourness plus vaporous clear is the insubstantial colour tainted with the vaporous clear light.

Colourness plus silvery clear is the insubstantial colour tainted with the silvery clear light.

The Encasement Light

Dark air of the interior is like cool, heavy dark air.

The inner encasement colours are an intense, hardened energy that dissipates as small pieces that separate and merge.

The outer encasement colours are a rough or rugged energy. They have a heavy, almost liquid consistency that will exist in small pieces that dissipate and merge.

The inner amber coating is similar to the other encasement colours' inner energy. It has a consistency like raw cabbage, or honey comb.

The amber is a heavy substance something like honey.

Light of the Body

The colour light of the corporeal body are substantial colours in their basic or spectral state with a bright or brilliant saturated nature.

Light of the Gold Square

The gold square light layers are the same colours and similar consistency as that of the encasement energy. They differ from these as they have a slight sticky or glue-like quality.

Internal Light Fibres

The gossamer or *vaporous* fibres are like gossamer that extends in wide, lengthy formations. These tend to extend from the upper midriff up to the neck.

The gossamer plus silvery-clearness fibres are the same as the gossamer fibres but with a silvery-clearness tint. These tend to extend from the upper midriff up to the neck.

The threads are like fine threads, that can also bundle. These extend centrally, though mainly from the upper midriff up to the neck.

The plumes are like thinly stemmed, rounded plumes with thread-like fibres. These extend from the central and lower midriff.

The velvet chords are like rounded velvet chords or belts. These tend to extend from the abdominal area of the midriff.

The substance fibres are simply substantial lengths. These tend to extend from the abdominal area of the midriff.

The strings or *colourness* fibres are like thin strings that can bundle or curl around. These extend from the abdominal area of the midriff.

The bright, saturated fibres are substantial lengths with a clear, bright, saturated appearance and feeling. They are flattened like thick tape. These tend to extend from the abdominal area of the midriff.

The thin wires are similar to the fine threads, but in a hardened, straightened form. These tend to extend from the abdominal area of the midriff, and fan out.

The stems are like a long, thick organic vines or stems, and may be imagined as around a half-inch thick.

The pipes are like light, straight pipes that do not curve. They may be imagined as around a half-inch in diameter, and are like a light plastic. They can also have flattened or squared-off sides, with varying solidity. These tend to extend from the abdominal area of the midriff.

The condensed cylinders are a light, colour substance, that may be imagined as cylindrical, and around three inches in diameter.

Encasement Light Fibres

The wires are like strong, metal wires that bend but do break or kink. They may be imagined as around an eighth inch in diameter. These tend to extend centrally from the abdominal area of the midriff, and fan out.

The rugged lengths are rough or rugged substantial extensions with a consistency similar to the outer encasement light. These tend to extend centrally from the abdominal area of the midriff.

The bars are like solid plastic or chrome, thin, straight bars that may be imagined as about an inch and a half in diameter. These extend from the inner central area of the abdomen, and fan out from there in multiple forms.

Singular Internal Light Fibres

The stem fibres are singular forces that have a slightly organic or light, rubbery feeling, something like a rat's tail. These extend as a single form from the inner central area of the abdomen.

The massed wires with core are the thin internal light wire fibres in a central massed form. They have a core similar to the stem energy. These extend as a single form from the inner, central area of the abdomen.

The central mass is a heavy substance in the case of the silver, and a medium weight substance as the other colours. They can have a slight chalky feeling, and may be imagined as five to seven inches in

diameter. These extend as a single form from the central area of the abdomen.

Singular Encasement Light Fibres

The massed wires with core are the encasement light wire fibres in a central massed form. They have a core similar to the encasement light bar energy. These extend as a single form from the inner central area of the abdomen.

Violet Rays

The rays are semi-thin rays of light that emit in planes that fan out.

The rays plus clear are the rays with a saturation of clear light.

The rays plus silver are the rays with a silver tinting.

Expulsion with colours

The expulsion of energy may be accomplished in a clear and systematic way by focusing on the energy as coloured light, without referring to any individual or specific event. The colours listed in the light tables may be utilised in this way to expel light from any of the specific areas of the entire anatomy. As long as there is an internal sense that one is expelling human energy single colours may be imagined in order to access all of that light that may exist within one's anatomy. Areas may be focused on individually, or in sections, in any segments or general areas one may choose. Eventually then the goal is to acquire the ability to expel a single

colour and cast or type of light from the entire anatomy in one session.

The body has definite knowledge of the existence of these colours and casts. One might think, for example, that expelling the black substance would also expel the encasement black. This is not the case at all. The differences between the consistencies and types of energy are a fact of the nature of this light, sensed by the body and inherent within the light itself, as it moves in masses that form based on its properties.

Through this colour-only method very large quantities of energy will expell from the anatomy in a single session. The quantity is almost always unpredictable, and these single colour masses can be large and forceful. Sometimes energy literally soars out of a vortex for a long, extended time. And the consistencies of the light are clear in experience. For example, the vaporous energy has a light feeling experienced throughout its expulsions, and the retrievals that follow will tend to be the same. Or, the silver light generally has a hard, heavy feeling, and its retrievals will tend to be similar. And the colours will sometimes differ in their masses and feeling. The most excessive quantities seem to be whites and browns. And the yellow light always seems to be a soft energy.

It is important to place significance on each of the individual colours and casts listed in the tables, and to recognise and sense the distinctions caused by dominant colours and their tintings and taintings. A blue plus crystallised-clear energy is a blue colour with a crystallised-clear aspect, which is a different energy than the

crystallised-clear plus blue. They are visualised and sensed differently, and will seem to exist on different levels.

If there is an interest in expelling more than one colour type at once it is preferable that this is done by maintaining a single dominant colour. There is no harm in combining the colours and types of light in any way within single expulsions, but if similar dominant colours and consistencies are combined the energy will tend to move in single or simultaneous masses.

Light can extend from its base-point to anywhere within the anatomy. Energy can be based, for example, in one of the outer spheres in front of the midriff, and yet fill the whole body. It will also be the case that energy that has been based in a vortex or area for some time, years perhaps, will extend most of its mass all the way to the bottom or top of the encasement, and even peel off in layers from the interior of the encasement, but still expel only upon focusing on the base-point. The central cylinder energy, such as that at the base of the sternum, will extend into the arms, and energy based in the head will extend into the stomach, etc.

The sizes of individual vortices are not necessarily related to their importance or quantities of accumulated energy. Small vortices can be a basis of large masses.

Energy that enters the anatomy is based and attached to specific places and vortices often through vulnerabilities and sensitivities, and is not random, or necessarily determined by the positions of physical sources.

Masses of energy will become very heavy and extensive at times, and tiresome. Light will move at various speeds, where these heavy masses will sometimes pour out of a vortex for some length of time, or slowly inch their way out of large areas.

Eventually an ability is acquired to expel one colour or type of energy from the entire anatomy in one session. This ability arrives when one is able to expel from all of the designated areas of the anatomy; of the vortices, cylinders, corporeal body, and encasement at once for one energy type. This may be done by fanning over all of the vortices one at a time, or in sets, then continuing to the cylinders, corporeal body, and outward to the frontal quarter, and encasement; though any order one chooses will suffice. The best methods, however, seems to involve beginning centrally, at the midriff, and internally, and then working outward. All energy of a particular kind or type will then flow out in an even stream.

Purification of the body and interior

The body and the interior of the encasement contain separate areas that require focus and attention. These include the corporeal body, vortices, cylinders, and spheres, and the phrenic fibres.

The corporeal body

The entire corporeal body in its physicality may be purified by fanning through it and through its specific areas. The physical body may be focused on through its individual areas, as designated in the

section *Light within the body*, while imagining its various areas as they actually appear in their correct places. It is purified in a similar manner as is performed on the other levels of the body, but one's intentions and visualisation are set on the physical level of the body. The entire body may be fanned over in one breath, or areas may be designated and focused on, through the discretion of the practitioner.

Purifying specific areas of the organic, corporeal body, including their related vortices, belongs to specific interests related to physical health, as well as to the general processes described here involving human energy. These medical interests are discussed further in the appendix, which involves the perception of a metaphysical level of foreign chemicals and radiation.

The energy of the physical body is a bright or brilliant, saturated and spectral light, as already described. For the purposes of purification, however, it is pictured as its actual physical appearance. And then following expulsions it will replenished itself with its bright, spectral energy. This energy often has a slightly rough or harsh consistency, similar to the encasement light. But while imagining its various areas during expulsions, the bones, muscles, organs, and tissues are pictured as they normally appear, unless their related vortices or cylinders are being accessed, which should be fanned over separately.

All of the internal organs are important areas of the body to cleanse and purify, and the organs that belong to the body's natural cleansing systems undergo natural upheavals within this purification process. This occurs physically and, importantly, through their coinciding

vortices. These will include the liver, heart, lungs, kidneys and adrenals, intestines, and spleen. In regards to the natural upheavals, the spleen vortices are by far the most significant of these, next to the liver and kidneys, and then the other organs.

The liver should be focused on in its full physical presence to expel any energy it may have accumulated. It is the heaviest accumulator of unwanted energy, in its physical presence and in its vortices, while the spleen is an issue mainly through the vortices. But the three vortices of the liver will upheave energy by themselves. These should be attended to as they occur. They will manifest as a dull pressure or burning sensation around the liver, which may belong to human or other chemical energy. The liver vortices are a place of deep effects of human substances, and it is good practice to go through one's past and purify these vortices.

The heart is a special case because expulsions from it, and on a lesser level from its vortex, can effect its rate of beating during the expulsions. This is not a danger for a healthy person. The heart vortex will also incur natural upheavals, though these will be few and far between.

The lungs and the two lung vortices at the sides of the body should be cleansed. The lung vortices also incur a small number of natural upheavals, which are not easily felt, and may be attended to by fanning over them for any pressures.

The kidneys are similar to the liver in these terms, and generally expulsions should include the adrenals and their vortices. The natural upheavals of the kidneys and adrenals can manifest as an aching pain in the kidney area, and sometimes a nausea or a fatigue. Fanning

over them in their physical presence and their vortices will release this energy.

The upper and lower intestines and the intestinal vortices, particularly the two large vortices, should be focused on in their full presences to expel any energy that may have accumulated in them. These vortices will naturally upheave energy, which will not be detected in an obvious way, but which should be released now and then.

The spleen is the most serious case of these areas that incur natural upheavals, and requires special and intensive attention. These expulsions demand attention, where the other upheavals generally do not, and may be done at any time. At some point during the expulsion process the three spleen vortices will begin to upheave masses of energy by themselves. These expulsions can occur on average twice weekly, but sometimes up to five or more times daily, though sometimes only once every two or three weeks. They have to be initiated, when pressure is felt, by fanning over the three vortices there. These are, for the most part, not human energy, and the expulsions have varying consistencies, sometimes unhealthy feeling, sometimes lumpy, sometimes acidic or vaporous. They are serious because they often manifest as something painful with symptoms similar to a dyspepsia, which may also include sickness and vomiting on rare occasion. The pain and pressure is always relieved immediately at the completion of the expulsion. They will last over an hour at times and can be difficult and uncomfortable, and generally require continuous attention. They can be hard and forceful, but the pain is not caused by the force, but by stomach acid that they produce. This pain and discomfort are relieved by a

thorough loosening of the energy at the vortex areas, which has to be done by kneading it; or, a simple antacid will always relieve the pain of these expulsions. These expulsions can go on to a point that can even be gruelling. They are something like sporadic bloodlettings that force their way out, and which go on for well over a year, it is estimated here; though this certainly depends on the person. And, as with the other vortex expulsions, these vortices will always replenish themselves after each expulsion. Unfortunately, because of these spleen expulsions, and because of the lengthy difficulty of some of the fibre expulsions, this process as a whole is not something one does with ease.

The thyroid and skin may also be included in this list of glands or organs that may be cleansed because of their natural accumulative nature. And then the rest of the body may be cleansed in any way required. The bones and teeth, for example, can accumulate masses of unwanted energy. All of these expulsions are accomplished by detecting resistances in the physical body. Energy that is naturally accepted by the body will not manifest as a resistance, and so expulsions of whatever kind will always be beneficial. This all has to be experienced and learned through practice.

The cones, cylinders, and spheres

The cone vortices are purified by imagining them as the shape they are filled with or containing any light or forces one intends to expel. The cylinders and spheres are treated in the same manner. The central cylindrical and spherical areas of the anatomy should be purified, as these are the centre of one's being and internal force. The central ball-like area within the gut is a place where deep

and permanent affects take place. The entire central cylinder area extending from the top of the head is important to purify, and the rung-like cylinders that surround them and extend through the body may also be fanned over. The vortices, cylinders, and spheres always then replenish themselves, and the rungs will strengthen and repair themselves immediately with a fine energy that tightens and intensifies this cylindrical level of the body.

The fibres

The fibre-like extensions at the midriff are the strength and force of this anatomy. They are forces of wilfulness, impulse, and interaction, as they are also potential forces of damaging and subjecting. And they can themselves be damaged and ruined. As already described, they have a Protean nature that exists in a shortened withdrawn state that extends and literally shoots out as forces and impulses occur. They can be cleansed and strengthened by fanning them and breathing while focusing on them. Deep silence can also free them from attachments and preoccupations.

Renewal of the body and interior

All light of the anatomy may be intentionally retrieved and renewed by accessing its place of rest that followed its expenditure, whether that energy is detached or undetached from its origin. In terms of ineffective light this is accomplished by accessing the coloured spheres, the reservoirs, and the place of the fibres at the back of

the encasement. Retrieval of effective light has already been described.

The colour spheres

The interior colour spheres attached to the reservoirs need only be fanned over gently or lightly while visualising their colours. Releasing these base-points causes the mass of related energy to also release. These base-points will be the same colour and cast of light as the energy of the mass, though generally these spheres need only be fanned over while imagining their basic colours.

The red suns

The large red spheres or 'red suns' existing in front of the chest contain base-points of colourness light related to the colourness reservoirs that has detached from its origin, as described in the section *Expended Light*, and as listed in the *Internal Light Tables*. They are fanned over in order to loosen this colourness reservoir energy, which will then return to its origin. Their internal spheres should be imagined as each of the colourness colours separately, as these may be accessed as if they exist on separate levels. Their surrounding small spheres containing base points of the blackness, whiteness, greyness, and clearness light may also be fanned over.

Retrieval from one's own reservoirs

The larger percentage of expended internal light accumulates within the reservoir areas, whether that be one's own reservoirs or those

of others. This energy tends to expend from the right side of the body more than the left, though this imbalance is not really an issue when retrieving energy, as both sides of the body should be attended to. One's own expended internal energy collects mainly within one's own reservoirs, and can be retrieved from them into the body. The ability to retrieve this internal light will depend on prior expulsion from the anatomy.

Retrieval from one's own reservoirs is accomplished by focussing directly on the reservoirs and not on the spheres, because the base-point of expenditure remains within one's own body. Fanning over the reservoirs to loosen the energy may be done as an inhalation or as an exhalation. Following this the energy will return to whatever place it had expended from within the body. Pressure may also be applied to the reservoirs with the light beams as the energy flows back into the body and vortices, as this pressure may be applied without fanning with the breath, and will do so by themselves causing renewals. The reservoirs either naturally release quantities of energy following expulsions, or that energy becomes available for retrieval. These quantities can be heavy and massive. For example, a heavy, lengthy tube of energy might force its way into the lower spine and up to the neck for some length of time, or large masses might pour into the liver or kidneys for extended lengths of time. The return of energy from the reservoirs will usually occur as single intakes from one area of the interior of the encasement into one area of the body. Following expulsions these intakes will occur naturally in some order immediately following one another.

Retrieval from others' reservoirs

Retrieval from others' reservoirs is done by imagining others' encasements with the reservoir areas, fanning over each of their spheres, and the reservoirs themselves, in any order. Focussing on the spheres will loosen energy that has detached from oneself, and focussing on the reservoirs will loosen energy that did not detach. One's own light will then return into the body, and this type of retrieval will often finish in a clear, succinct way.

The fibres

The fibres are renewed and rebuilt by loosening them from where they stand, as they will all lay or rest vertically along one's own encasement or that of others. They will always have been drawn or forced back onto the rear half of the encasement, as depicted on page 64. This renewal may be accomplished by focusing on any of the 279 individual types of fibres, as their colours and consistencies, or they may be focused on in more general ways. Imagining them simply in the place that they stand, or as a single colour or type will generally access masses of them. Positioning of the other's encasement may be done in any way, as already described, and it is possible to set the other persons light entity facing away from oneself to access the rear of the encasement. This causes the fibres to flow in a direct way. Repairing these is experienced as a definite feeling of their extensions being built up or fortified in front of the midriff area. Renewal of the fibres will also often be followed by repairs to other areas of the body and encasement.

Reflective light

The light and energy described as reflective light on pages 43-45 is treated the same as the other reservoir light. It is renewed by focusing on their related spheres within and surrounding the red suns, or by focusing on the bright whiteness light or the whiteness reservoirs, with their coloured and clear consistencies, and the blackness light and greyness levels with their coloured and clear consistencies. These also include the clearness light and clearness reservoirs. This will retrieve one's light from within one's own encasement or from others. Expulsions of these levels of energy from within the body will also initiate natural renewals of this light. When discerning the places or times of the expenditure or accumulation of this light it may be understood as involving aspects of one's attention and reflection.

Silver light

The silver light and energy is treated the same as the other reservoir light. It always has a heavy feeling, at times literally like liquid metal. It is the psyche's deepest most forceful light. It is renewed by fanning over its reservoir below the encasement, or by fanning over this reservoir on others. Its silverness spheres exist within the red suns along with the other colourness spheres. This energy can be forceful when being intaken, and may be felt pouring upward into the body.

Corporeal light

The bright or brilliant light of the corporeal body is naturally retrieved into the body when the physical body is cleansed or purified. It accumulates in the same places as the reservoirs and is renewed by fanning over the far clusters, depicted on page 54, or by focusing on the areas of the main coloured reservoirs. It exists only as basic or spectral colours and often has a slightly harsh consistency.

Purification and renewal of the encasement

There are five distinct repairs of the encasement, occuring during purification, and two types of energy movements involved in these. There are renewals of the encasement layers, both inner and outer, repairs of the petals and balloons, and renewals of the gold square. The movements of light during these renewals includes the return of energy to an area of the encasement, or the repair of the encasement in whole ways in the cases of the petals and balloons, wherein the whole egg structure is rebuilt in single movements.

The gold suns

The large gold spheres or 'gold suns' positioned outside of the encasement contain base-points of light related to the encasement energy that has detached from its origin, as described in the section

The red and gold suns. These are fanned over in order to loosen the encasement layer energy, which will then return to its origin.

The encasement layers

Renewal of the encasement layers occurs in the largest quantities due to expulsions from it. Purification of the encasement is accomplished by fanning over its entirety, focusing on its shell-like form, while imagining any effective energy or light existing within its shell, as already mentioned. Intentional renewal of the encasement is accomplished by imagining the gold suns or encasements as each of the encasement colours, fanning over these spheres, or the encasement itself. Focussing on these spheres of other's anatomies will loosen energy that has detached from oneself, and focussing on the encasement itself will loosen energy that did not detach. This encasement light will then return to its origin. And the reverse is done to loosen others' encasement energy that has accumulated on one's own anatomy.

Because this retrieval occurs exterior to the body it requires an unusual sense that one has to acquire. For the most part encasement renewals occur by themselves, and expulsions will cause this natural repair and renewal. Decay of the encasement that does not attach to others remains outside of one's own encasement, described as the external fragments on page 47. This energy may be pulled back onto oneself by breathing and imagining the colours of the encasement layers, from where one is or by returning to events in memory in which a loss occurred. The silver and clear encasement energy seems to strengthen and tighten the layers. And the inner layers are the more intense energy, and will sometimes repair

through the interior of the encasement. In general renewal of the encasement energy requires no special attention, because expulsions will initiate its natural and most intensive and massive repairs from wherever its energy is.

The petals and balloons

The encasement petals and balloons repair, to a large extent, on their own, due to expulsions. These renewals may also be accomplished intentionally. The petals repair from their places of decay external to the encasement. They tend to simply unfold, as some pressure or force occurs on or within the encasement, and remain in place along the rear crevice of the encasement in this unfolded state. But masses of them also accumulate, in this same place and position, on others' encasements. This movement to others seems strange, and is not completely explained here, but it becomes apparent when one draws these back from others. These intentionally initiated retrievals, may be of some concern in the beginning, and may be slow and difficult. And so those methods are described here.

The petals may be repaired from oneself by breathing and pulling them from behind the shoulder, from the right and left. These repairs can be done one layer at a time focusing on each colour of the encasement, or all at once, or in any combination. Once the light is pulled into the area behind the spinal column, a repair is initiated which will occur naturally, but also may require assistance through breathing or pulling. The petal aspect of the layer will wrap itself around from the spinal area to the front of the encasement. If it is not assisted it may take some time to wrap

back around the encasement, which will be felt occurring on and off. But it may be pulled intentionally around to the front by breathing and pulling and imagining the colours, from the sides until it sets itself in the front.

The best method of repairing the petal light from others is by positioning the other's light entity such that the crevice at the back of the encasement is accessible. The other's encasement may be positioned in any way, but viewing from the back of the encasement, and fanning over this area initiates the most expedient retrieval. This may also be done while imagining the colours. Then the petal light will return to its origin, or may be pulled back onto one's own encasement by sustaining a pressure against them.

Once repair of the petals becomes immediate and expedient the only attention they may require occurs when they become awkward. At times their repair will be large, heavy quantities of light, and at other times subtle. But because of their form they sometimes will turn in or around in awkward ways as they wrap onto and around the encasement, which will require a pressure maintained against them during the repair. With time this wrapping becomes immediate, and any pressure, pulling, or breathing becomes unnecessary.

As a reverse procedure, others' petal light that accumulates at the back of one's encasement is expelled by fanning across the back of the encasement intending the force to release its energy.

The balloons have been given this name because they are like thin, whole forms that encompass the entire encasement. As effective energy they are exchanged between persons by simply moving to

others' encasements. They may be expelled or retrieved by fanning across the entire encasement at once, intending to dissipate their presence or to loosen them from others' encasements. Generally they do not require any attention, and they return to one's own encasement naturally following expulsions. They reinstate as a gentle popping sensation onto the encasement, seemingly returning from somewhere surrounding the encasement.

The gold square

The gold square located at the front of the encasement requires purifying and rebuilding. This is done by focusing on its layers, in the same manner as is done with the encasement layers. Its energy, when it exchanges with others, enters this same frontal area of others. It is composed of the same type of heavy energy as that of the encasement, though it has a sticky or rubbery feeling and consistency. This area of others should be fanned over causing this energy to pull out of one's own anatomy, which sometimes occurs in a slow, difficult manner. All energy types should also be expelled from it and its surrounding area, which will have based there and extended into the encasement and body. Following expulsions its energy will at times pour back onto it heavily for extended lengths of time.

Language and words

Words can be accompanied by forceful affects in terms of collections or quantities of ethereal light. Effective energy

exchanged between persons is often accompanied by words and language. This exchange is dependent on the proximity of the other person, which occurs in terms of this anatomy, and not necessarily in physical terms. That proximity is decided by a familiarity, history, and an openness or vulnerability. Two persons talking on a telephone, for example, can exchange energy almost as if they were physically close. And though the degree of openness would generally be considerably less, the fibres can also be permanently affected in this way.

The energy of words and sounds often enters the vortices. The liver vortices are a particularly vulnerable area to this, for unexplained reasons.

With this knowledge these effects can be intentionally directed and performed then. And this light can be intentionally directed to places in one's past, or reasserted there. This belongs to an occult area involving words and speech, separate from this purification process. It is the case that, through occult practices, human ethereal substances can be exchanged between persons with no physical or verbal interaction, though some past proximity is necessary. The fibres, however, cannot be affective in this manner.

Words can also be helpful with performing expulsions, in lieu of utilising the colours. Masses and mixtures of light often belong to a feeling that can be known with words. One may then have a thorough grasp of these feelings, expelling them, for example, as the feeling or feelings of x, x itself, the memory of x, and feelings attached to x. These methods also belong to an approach separate from the practices described here.

Abstruse structures

Images of wood are an archetypal way the psyche imagines, as it perceives, or may imagine for itself, forces within one's infinite field or spatiality that are not coloured substance. This occurs naturally, the same way other aspects of this metaphysical infinite manifest as particular imagery, repeatedly, and universally, for mysterious or unknown reasons. These forces are a mysticism that have no energetic existence that is explained here or based in this anatomy. It is explained through the idea that human beings have an affective structural nature, in this sense of the daemon, or of this other entity, that is structural but not coloured. It is explained here as force that is present but is not vibration as colour.

There are three types of images, contained within or related to this vessel-egg, that pertain to its deepest structural affects; two of these illustrated here on page 135, and the third pertaining to the cylinders and spheres illustrated on page 33.

The first involves the existence of a structural force, simply as such. It is altogether invisible energy, that is geometric in form, and is real force that has permanent affect. It should be imaged as straight-cut pieces of lumber—as planks, plywood, and board. This imagination will give the psyche the ability to access these forces, which are experienced as strong resistances. They exist in history as permanent structural changes in one's own field that other persons are able to cause. Their dissipation is not an expulsion of energy, but simply the breaking of something, that dissipates following which the area the force existed within rebuilds itself.

This breaking is a simple act done in the same manner as the expulsions, and it feels as if something is expelling from the anatomy, though not as a substance. The image, which varies, as what is shown here is only an example, has to be imagined clairvoyantly, or sensed, or guessed at, and then fanned over, as if the other person were centred within this wooden structure.

The second deep, structural form is something like an upside-down, stemmed vase, that stands at the bottom centre of the encasement. It forms a cylinder that extends up through the body, through the central cylinder vortex that also includes the central spheres there. It is a centrifugal and grounded force, and a distinct intense, heavy, metallic energy, that always exists as any of the encasement colours, plus the six alternate internal colours of blue, light green, and dark green, red, orange, yellow, as listed here:

Grey	Black	Violet	Turq-uoise	Forest Green	Cobalt Blue	Mars Red	Brown	Pink	Silver	Copper
Clear	Gold	White	Amber	Blue	Light Green	Dark Green	Red	Orange	Yellow	

This energy also extends into other persons' anatomies. The full cylinder shown here should be imagined as any of the encasement colours, and as solid energy, though it is always an intense metallic liquid. These are, perhaps, the most important substance expulsions to perform, as they are the most forceful and damaging substances. They are deep effects a person may have, and occur at the same moments as the fibre insertions; though these deeper forces are a person's central assertion that may have effect on their own, while the fibres are more of an extension, a manner of getting-at things.

This vase and its stem and surrounding area are fanned over, or this column may also be pushed against until it dissipates, which can take several minutes, and may have to be repeated. On rare occasion these expulsions will be very intense and slightly painful if they are centred in the abdominal area. This light also accumulates as expended light as a parallel cylinder directly in front of the body, being a type of reservoir between the pink reservoir and the body.

Both the wooden forms and the stemmed vase are structural forces that are not on the same level as the peacock's egg. They are, however, intense and deep effects a person may have, and occur at the same moments, or same kind of moments, as the fibre insertions. This vase and its stem and surrounding area are fanned over like the wooden structures.

The third deep structural form that can have an affect is the rung-like cylinders and the internal spheres existing on their level. They can emit their fine, structural matter that is like a slightly dark, clear substance, something like fine grains of glass or plastic. It may be treated in the same manner as the stemmed vase.

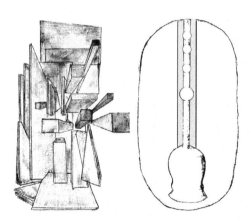

III
The Radiance of Colour

A colour graph designed in terms of time, force, and inclinations summarises the expenditure of alchemical or ethereal light:

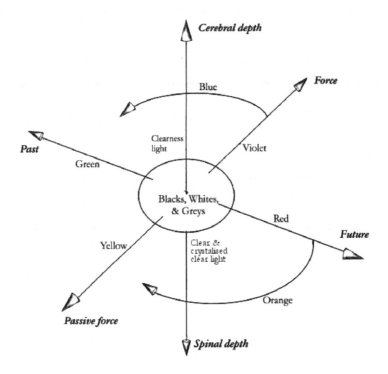

The human psyche, compared here to the force of the 'wheel' and colour wheels in alchemy, expends violet and yellow through its nature as force in its spatiality, and expends red and green through its perceptual nature in its temporality. This combination of a perceptual 'look' and force is placed at the most immediate level

of the psyche, wherein an expenditure is always active. The look and its temporal emphasis also contains force through its spatial emphasis to some degree, and the force likewise contains look to some degree, so that this circularity is fluid and gradual. And these movements are immediate inclinations in which the look is simply a looking-toward within the structural infinity of this light.

This is the perceptivity of the human daemon, the invisible side of human being, which is essentially the otherness of this anatomy as an entity. The look and force are contained within this metaphysical anatomy through its visceral, perceptual nature and its forces. The essence or nature of this coloured light is described within this spherical graph as a force-look; as both force and perception. Light acquires colour here upon its expenditure, which may be understood as pathos, where 'pathos' is used in a philosophical sense of all psychical experience. And this movement and vibration gives it its substantiality and affectiveness.

Blue is expended as force combined with a past-looking, and orange expends as a 'passive' force combined with a future-looking. Otherwise a past-looking is green or green-yellow, or a future-looking is red or inclines toward violet. Violet is given here as expenditure as pure, coloured force in itself. Yellow is expended as the tendency of energy to colour as it is inclining from force, but as force itself.

In European alchemy theories developed in which all colours were thought to derive from blackness, whiteness, and redness, originating from the idea that darkness and light mix to create colour. This was a basis from which Goethe, the alchemical theorist Athanasius

Kircher, and Rudolph Steiner derived colour concepts. Red was often given a privileged place. In Robert Fludd's colour wheel redness is involved in the creation of red, yellow, and orange.[1] Goethe also gives red a central place involved in all colours:

> Whoever is acquainted with the prismatic origin of red, will not think it paradoxical if we assert that this colour partly *actu*, partly *potentiâ*, includes all the other colours.[2]

This red has a violet nature for Goethe, that has been compared to the colour of peach blossoms. Here, within the interior of this anatomy, blackness, whiteness, and greyness are a basis of all colours, wherein redness is given a privileged place through a futural-looking nature of the human psyche and its internal colour expenditure, and through violet as its pure force. Goethe's interpretation of force into colours differs from this graph. He assigns a passive negativity to blue and an active positivity to yellow. In this graph violet is given a privileged position of force wherein it has an unfelt nature, as a neutrality. This neutrality is temperate in nature, accomplished through the combination of opposing temperatures of blue and red, and not through a 'negativity' or 'weakness' of blue, as assigned by Goethe. Yellow is opposite in force to violet and therefore differs from the 'force' and 'action' Goethe assigns to yellow, if these were compared.[3] Goethe equates the warm/cool opposition of colour with active/passive to some extent, where here this kind of temperature is not a measure of force. Their forces are understood through an active coloured vibration which may possess a 'passivity,' but wherein their force is not discerned through optical observation of colour, as with Goethe.

Each point on this graph then represents a point of reaction or a point of intention. A point of expenditure, originating from a cerebral depth for example, and attentively arriving at its position of colour, or moving through its positions of colour, would be either reactive or intentional. The difference between reactive and intentional are simply defined as either coloured light which originated from a reaction to affective light or as coloured light which did not. Any colouring or vibration of emotion or feeling are then understood within these points wherein an extension into presence and reflection may occur, and which would involve all experience and thought.

The following is a further depth of categorisation of the expenditures of human energy, each colour having seven basic inclinations:

1 Its immediate inclination as a single or spectral colour.

2 Its serene inclinations represented by the encasement colours.

3 Its emotive inclinations as any combination of colours.

4 Its attentive or apprehensive inclinations as whites.

5 Its comprehensive inclinations as blacks and greys.

6 Its intensified inclinations as levels of clear light.

7 Its striving, willing, or creative inclinations as silver light.

These levels all combine in a fluid manner, together with the coloured movements described in the spherical graph shown. Blacks, whites, and greys through these levels contain a reflectiveness

wherein their mixtures with the clear consistencies intensify them creating the silver or mercurial light. These give further levels and gradations of expenditure to the colours in their emotive natures. Blackness may also be defined as a 'knowing' or a having or holding-knowledge-of, as a comprehension, and black is the movement of this into a substantiality, wherein all colours, in their substantial state, expend based in this blackness, as seen by the anatomy's reservoir configuration, and similarly contain this kind of movement into a substance. Whiteness contains reflection and perception, and white a substantiation of this as movement to presence and attention. And greyness contains a stabilisation and conceptualisation through this comprehensive and attentive or apprehensive light. Silverness then forms as these intensify through the clear and clearness lights. This silver energy is the most forceful energy, in terms of actual force as movement, where the force of the violet, as well as the other colours, is a force of colour itself, as its force and affects are intrinsic to its presence. Violet and pink contain psychical unfelt and felt forces, where a neutral violet is emotionless in some sense, and pink contains a kind of agitation.

Though all of the light is potentially force or forceful through the forces of the psyche, the violet and pink are psychical force in itself on the level of the light itself. Yellow is also force in this sense, as passive force, which may also involve a heightening in this passive-force sense. Browns contain mixtures of colours in all of their possible mixtures wherein single colours loose or tend to loose their dominance. These all take on serene, balanced, or natural states in themselves through the encasement colours, and through the amber light, which is a special matter belonging to a balancing and justification, discussed in chapter IV.

The colours in this graph may be understood in terms of speed, as the circular, recurring speed of this light. In general, the serene colours of the encasement are of a lesser or slower speed or vibration, and the primary colours of the interior are of a higher speed. The serene colours exist as opposed or juxtaposed to the primary colours within a curved spectrum, that renders a particular offset, which is also a serenity in the temporal pace of their circularity, that is also a powerful naturalism. It is one of many possible offsets perhaps, but is nevertheless the curve held here to belong to the human aural field.

Then a purification of this anatomy results in an intentional internal light and a serene encasement. This catharsis is metaphorised as the purification and sealing of the alchemical vessel. This belongs to the alchemical process in which the vessel or crucible is initially open and unsealed. The vessel is open to affects throughout one's lifetime which becomes an issue within this process as part of the alchemical putrefaction or blackening. And through an alchemical process and catharsis this vessel of light, or retort, becomes reconstituted, and sealed or closed, and solitary within its infinity.

On a separate level of colour definition a red/yellow opposition has a place within this anatomy, associated with the red and gold suns of this anatomy. Jung notes that the alchemical "yellow (*citrinitas*) often coincides with the *rubido*."[4] They are colours often associated with the gold and final stages of the alchemical *opus*. They are also the warm colours of the primary colour triad blue-red-yellow, and hold originary opposition in this primary and temperate sense. This opposition is also referred to by Nietzsche's Zarathustra: "Deep yellow and burning red: that is to *my* taste—it

mixes blood with all colours."[5] And Heidegger refers to this opposition in reference to Nietzsche's experience of the Eternal Recurrence: "Colour, the very look of things, their *eidos*, presencing, Being—this is what changes. 'Deep yellow' and 'incandescent red' begin to radiate."[6] 'Red and gold' also have meaning and history within the mysticism of Rosicrucianism. Occultist Aleister Crowley expresses the uncanny image of a red and gold: "So bright we could not look! But behold! a blood-red rose upon a rood of glowing gold!"[7] And Nietzsche's Zarathustra is "like a dead man" for "seven days" and his eagle brings him: "yellow and red berries, grapes, rosy apples, sweet-smelling herbs and pinecones,"[8] where the pinecone refers to the Dionysian thyrsus. Red and gold take a privileged place within this anatomy, through its red and gold suns.

The pure or serene radiance of this light occurs through the alchemical solitude, which brings itself to light through a darkness, and the human shadow, essential to the *opus*. This solitude belongs to phases within the *opus*, involving an experience of a solipsistic[9] light of sun. The alchemical solitude dates back to early medieval alchemy according to Jung, called the *solificatio*, where "the initiand was crowned as Helios."[10] Solitude, and the seven solitudes, belong to phases of the *opus*, which contain Illuminations and alterations of light.

IV
The Amber

Purification or catharsis here refers to a purity of the daemon, and purity of light. This light, metaphorised by the sun, contains the possibility of an oppressive impurity, as the black sun. Through an understanding of the amber of this anatomy there is, along with its basis as human affect or attention, or pathos, an inherent balancing nature, which may be understood as its ethos. 'Ethos' is understood here similar to Heidegger's definition, interpreting the early Greek, as abode or dwelling place. It is one's nature as the habitat of the soul, or of the psyche. This balancing becomes, through life, and acts of life, imbalanced as an oppressive blackening that may be justified, or adjusted, through this catharsis.

In Sophocles' *Oedipus Rex* certain laws exist in the heavenly ether.[1] A particular balancing, ethereal nature may be associated with the amber ether of this anatomy. 17th century alchemistic theorist Thomas Vaughan describes amber as it related to the Dionysian mysteries:

> Amber is a solidified resinous gum, and is commonly full
> of electricity. It was supposed, in the hands of those
> gifted correspondingly, to abound with the means of
> magic. In this respect it resembles the thyrsus or
> pinecone, which was always carried in processions —
> Bacchanalian or otherwise—in connection with the
> mysteries.[2]

'Amber' in Greek is *êlektron*, meaning 'substance of the sun.' It may be related to honey, and the alchemical honey and honey bee. And it refers to an ambrosia. Jack Lindsay notes: "Honey is a preservative, a form of ambrosia, a *pharmakon*[3] giving mantic power—."[4] Kerényi relates honey to a divine amniotic fluid.[5] This ethereal, ambrosial substance contains a particular alchemical quality, understood here as the balancing, and perspectival balancing nature of this soul-vessel. Crowley gives amber a kind of cathartic nature, and temporal place in the day: "Gold amber suggests the mellowness of harvest, which is the perfection of the rose-pink of dawn, the spring of the day."[6] It is the substance of tragic catharsis that renews, balances, measures, and positions the human psyche, in its paths, and its fate, and fateful dream images.

The idea of a surrounding ether of this kind has basis in mysticism, in the form of a specific energy or ether. It has basis in Kabbalistic theory, and was known by the Greeks. Scholem notes that 16th century Kabbalist Rabbi Menahem Azariah Fano refers to "an occult ether or air" in which "all human actions are recorded as soon as they are performed."[7] It is a "sapphire-coloured ether surrounding [a man]." And he relates it to "the contemporary doctrine of *ambiens nos aer*," and the idea of *to periexon hemas*, or 'that which encompasses us,' used by Galen. Sapphires are, in rare cases, an amber colour, but the reference to the sapphire originates from the Kabbalistic *Sephiroth*. It is not a "uniform cosmic ether, as in Indian notions, but an aura surrounding the individual *tselem* at certain times." This ethereal understanding originates from the "doctrine of the *tselem*," or astral body; which is also related to the *tsel*, 'shadow,' and to *tselamim*, 'images,' through an etymology. The "shadow is the external projection of the inner *tselem*."[8]

The black sun originates from a dark pathos or force, an imbalance hidden in its nature. Its darkness originates from the human shadow. Jung associates the pride of the peacock with "the overweening pretensions of the human shadow,"[9] which may be seen as an understanding of hubris, enacted through the human shadow. The shadow is both the source of human imbalance, while it is also the profound otherness of the psyche and its occultism. Here, however, the concern is with its imbalancing hubris. This may be understood, through its spectral nature, as a 'disrespect'; though in a mysterious, daemonian, and perceptual way. It is disrespect through a reciprocity of the daemon's light and realm, a circumspection that acquires force, and degree of force.

The English 'respect' derives from 'spectre,' an image, vision, ghost, apparition, and the French '*specere,*' 'to look at.' These are also the root of 'circumspect' and 'perspective.' The prefix 'per-' means 'through' and 're-' denotes 'back.' 'Perspective' means to 'look through' and the Latin *respectus*, or 'regard,' is literally the act of 'looking back at one.' The psyche is understood on a spectral level as something that perceives, and visually perceives, and turns or pivots, within its contendings.

And then perspective, which is also the Greek *doxa*, pertains to this perspectival circumspection, that may act, or exert force, in a balanced or imbalanced way. *Doxa* means the particular view or perspective one has, in the purely visual sense in its earliest forms, and then also as one's point of view in a general sense; and then it means one's position in the accentuated sense, of standing or stature.

This amber ether then involves a fluidity and a complex mystery, because this amber light involves both the adjoined and distant or adverse. It is affective as a joining with others, or as an imposing or imposition with others, either of which can be, in some sense, a kind of love or togetherness, or it can involve distance or adversity, that does not join or share its light. And then any of these, within their degrees of jointure can involve this shadowed, distorted, or imbalanced 'disrespect.'

And so it contains a mysterious nature of its own, that is perhaps indecipherable, but which exists nevertheless as a kind of truth or purity. It appears as the pathos of a justification, when justification[10] degrades, one might say, though that degradation and imbalance may not be felt. Coloured light is essentially vibration, and the amber vibration may then also be seen as a hidden vibration wherein an assertion extends beyond a limit that imbalances, as a type of hubris. It is a hidden imbalanceing that will eventually balance itself, and which may be balanced intentionally.

The dissipation of this light is then a kind of justification, and perspectival justification, as a surpassage, and adjustment; this being be found within an imbalance which returns to an equilibrium. It is also thought here that Greek tragedy had this kind of intention, as an act of the *phamakeus*.

There is a *pressure* of feeling wronged by another that is partly decided by this definite quantity of amber, both in its inner-hardened and outer-substance forms, which may be intentionally expelled from the encasement of another's anatomy, in their physical absence. It quantifies from within the interior of the other's midriff

at its source near the liver area, and accumulates on the right side of the encasement, or anywhere on its surroundings, as shown in figs. *a.* and *b.* on page 148. It may be directed toward infinity with the other imagined at any position. It can also have a bright red tint or intensity to it. This light, when expelled, will initiate intakes, as its pressure also causes a decay, and as its expulsion is properly a purification, and catharsis of one's own solipsistic infinity. Most of this energy will dissipate off the other's light entity, though it may also expel then from within one's own encasement, in which case it belonged to an adjoining.

The amber light, as the human perspectival light, has three areas of emphasis. Like all of the encasement energy it may affect any area of another person's anatomy, but it has three areas related to its perspectival behaviour. The first is the encasement itself, as already described. The second is a spherical cross-area at the lower back of the encasement, called here the 'amber assemblage light,' shown by fig. *b.* And the third is located at a spherical vortex at the upper front of the encasement, called here the 'amber guiding light,' shown by fig. *c.*

The amber assemblage light is located at an area Castaneda calls the 'assemblage point,' and at a spherical cross-area just below it. The assemblage point is a perceptual unifying position which is a sphere of light, and spherical vortex, that has an actual existence, external to the human body. He locates it behind the right shoulder blade of a human being, in its normal state, and it changes position when the body dreams, and does so profoundly in *dreaming*.

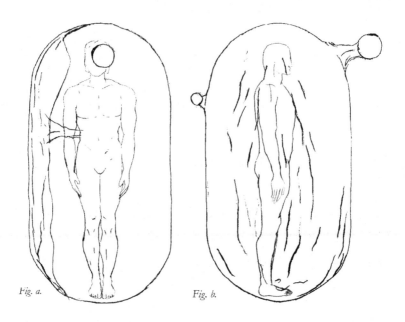

Fig. a. Fig. b.

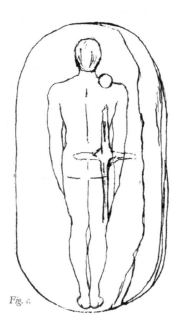

Fig. c.

It is a spherical vortex that exists, attached to the encasement, or just outside of it, as shown in figs. *b.* and *c.* It is surrounded by the amber light, and, apart from this issue of the amber ether, all types of energy may be expelled from it, including human and foreign energy. Energy will exit it in long streams having portions within the encasement, following which it replenishes itself. In alchemy it may have been depicted as an eye or sphere with wings, as in the Jamsthaler woodcut shown on page 19. It is the perspectival place that determines perception, and is then the internal or hidden perspective of the body, and is itself what we are and exist as, at any point in time.

This spherical vortex is also the centre or basis of the structural energy described as wood in the section *Abstruse structures*, and should be recognised as such when it is dissipated. This point is the centre of one's structure, and it is treated separately during the expulsion process, since energy of all types may be expelled from it. Others' fibres in particular are drawn to it as the deepest type of effect they can have, and should be expelled by focusing on it and particularly the area surrounding it and just in front of it.

This gathering point has basis in Heidegger's investigations into perception. A perspectivism within the soul that is distinct from the human body has basis in his thought through analysis of the senses and Plato's *Theaetetus*. It is human "precursory perceiving" through which the "soul holds up the *singular* region of perceivability into which everything perceivable converges and is held in unity and sameness."[11] He argues this precursory converging in terms of the senses inability to unify human perception in themselves, and in terms of the excesses required for perception; for example by

the fact that the senses perceive colours but cannot perceive colour itself. And this has a parallel in Nietzsche's *Thus Spoke Zarathustra*, where the body is a "multiplicity with one sense" and is a "herd and a herdsman."[12] The unification of the senses and of the body is a shepherd, a hidden mercurial self that determines perception.

The amber assemblage light also has structure below this assemblage point area, in the form of a circular or spherical cross-area that extends vertically and horizontally. It exists at around the level of the waistline, as shown in fig. *c.* This light, as with any of the amber light, can have an adjoining nature, extending to the same area of the other persons. The cross-lines may be thought of as alignment lines, in their nature as forces. When this area's cross-lines are fanned over on another person's anatomy the amber energy will expel and pull itself out of the rear area of the encasement on oneself.

The amber 'guiding' light has an existence at a frontal sphere, that hovers between the gold suns. It exists centrally in front of the encasement around the height of the head, as shown in figs. *a.* and *b.* This sphere is also a vortex, surrounded by the amber light. It may be purified of any type of human or foreign energy. And the amber light surrounding it also has an adjoining nature.

This light of assemblage and this light of guiding exist as the perspectival basis of human being and being in the world. Both may be associated with one's light of path, or light of striving, or of will, as persuesion or perspectival position, and Being.

These areas, in a negative way, can then necessitate, impede, and dissipate the psyche or will, through persuasive weight, as they are maintained by the amber light, and by other's light.

As a further understanding, the nature of this amber purification and renewal is not merely a balancing, but also has an aspect of surpassage. The nature of the adversity and adjoining of amber light is not merely measured by a distance or difference, as if all beings are equal, at all times. Its measurement includes perspectival light as diminution and magnanimity. Its perspectivism, through its hidden point and its perspectival realm, is not merely perspectival position, but is also degree of magnanimity.

When Zarathustra prepares to climb his high mountain in 'The Honey Offering' he has "honey ready to hand."[13] The mountain path is a surpassage, taken by the adept, who surpasses the perspectival levels of those who cannot withstand its height and nature. And the adept reaches the height of a fateful perception, that is formed there and changes there. It is a justified attainment, as Nietzsche states, quoting Zarathustra:

> Zarathustra possesses an eternal right to say: "I draw circles around me and sacred boundaries; fewer and fewer men climb with me on ever higher mountains: I am building a mountain range out of ever more sacred mountains."[14]

This eternal position and its remote gathering then becomes a summit-abyss within the *opus*. The practitioner achieves a balancing through this tragic surpassage, as an occult serenity is found there. This pathos of distance is then surrounded by a metaphysical death, as it expresses one's own state of being.

Nietzsche describes a moment of aporia, that leads to "the road to the Hyperboreans." It is beyond the ice, and beyond death:

> We thirsted for lightning and action, of all things we kept
> ourselves furthest from the happiness of the weaklings,
> from 'resignation' There was a thunderstorm in our
> air, the nature which we are grew dark—*for we had no
> road.*[15]

It is the experience of Oedipus whose fate leads him to an impossible existence. An impossibility then becomes the nature of existence itself, for Zarathustra:

> You are treading your path of greatness: no one shall
> steal after you here! Your foot itself has extinguished the
> path behind you, and above that path stands written:
> Impossibility.[16]

And he reaches his high mountain abode, and climbs the alchemical Mountain of the Philosophers. Nietzsche finds this abode in his verses of *From High Mountains: Epode.*[17] In the "garden of summer" he waits for his friends, upon the glacier which "exchanged its grey for roses." There he tastes the "sweetness" of his "honey," as he becomes a "ghost." His friends knock at his "window," but they have become apparitions. And as the "wedding day has come for light and darkness," he awaits new friends, within the circles of a new pathos and ethos.

V

Phases of the Opus

The illuminated wheel

There are seven levels of attainment marked through the Phases of the *Opus Magnum*, undertaken in two cycles. The first cycle attains the alighting, and the second attains the will. Both cycles complete the *lapis*:

	ATTAINMENT OF THE ALIGHTING	ATTAINMENT OF THE WILL
Noon	*The time of the initial vision and light that is one's starting point. Dreaming is accomplished.*	*Dreaming acquires the images of the alchemical process.*
Putrefaction	*The vessel is open as the cast shadow permeates its interior. The eclipsed or blackened sun illuminates the opus.*	*The shadow takes an occult form, and the black sun is dissolved. Renewal of the amber light.*
Twilight	*The image is relinquished, and the vessel or structure is revealed and experienced.*	*The structure is fully attained and made central.*

Purification	*The purification is undertaken without the alighting.*	*The purification is completed. The vessel is closed.*
Midnight	*The quintessence of the peacock's egg is apprehended.*	*The quintessence of the dove's egg.*
Formation	*Formation of structure and body.*	*Constellation, gathering, and logos.*
Dawn	*Initial alighting. Access to the ethers is attained.*	*Final illumination and will.*

These phases, through which the *lapis* is attained, belong to an awakening and maturation of the spirit and daemon. Because of the metaphoric representation of the moment, and of the emphasis on perception, image, and experience of light, they are related here to times of the day. Dawn and noon are a brightening and appearing while twilight and midnight are a darkening and blackness. Dawn and noon are also then presence and manifestation while twilight and midnight are withdrawal and constellation.

Each phase is a full moment and temporality in itself wherein light and dark manifest, so that this wheel also spirals. Height and depth are then ever-present within these phases, as noon is an ascendance while midnight is a descendance, wherein this wheel spirals through varying shades of Illuminations.

For the alchemist these phases are often defined through movements of colours, from the black of the putrefaction to an ash-grey, a twilight of blue-green to red, a red-yellow and the colours of the peacock's tail, and violet dawn, or red or red-yellow dawn, and a gold. There is also a white phase of purification. There are various versions of these colour sequences in alchemy's history. Jung describes the coloured stages of the *opus* following the putrefaction:

> . . . the washing (*ablutio, baptisma*) either leads direct to the whitening (*albedo*), or else the soul (*anima*) released at the 'death' is reunited with the dead body and brings about its resurrection, or again the 'many colours' (*omnes colores*), or 'peacock's tail' (*cauda pavonis*), lead to the one white colour that contains all colours.[1]

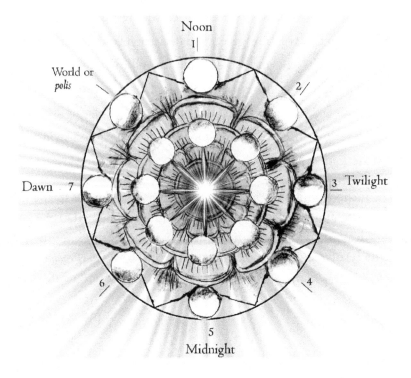

The seven phases of the *opus* are solitudes, as they set into stages deep or remote experience. This segmenting of the *opus* has been understood in various ways; as the biblical days of creation, the number of classical planets, or as seven metals. There are also larger numerical segmentations in alchemy's history, through the signs of the zodiac, the number of Christ's disciples, or the phases of the moon. And the *opus* was sometimes interpreted into only three or four stages, or reduced to the natural elements, as it was in its earliest forms. The alchemical wheel has early origins and may be associated with the Ouroboros, and with the pentacle, both having archaic basis. In Crowleyan Thelema the *opus* is left somewhat open

as the stages vary depending on the practitioner. The phases are also often given titles related to chemical activities. An example of this in series might be: Calcination, Dissolution, Separation, Conjunction, Fermentation, Distillation, and Coagulation.

These phases or levels are perspectival-perceptual attainments. This perspectivism may be seen as extending from the central spheres of this flower-wheel, outward to its illuminations and Illuminations. It is the line that extends from perspectival point to the vanishing point wherein the image is structurally attuned and reciprocally attunes to its light of sun. In this way the alchemical wheel represents the soul or psyche, as perspectival being that radiates its full presence within each phase of the *opus*.

The phases of the *opus* are accompanied by dreams related to their movements or attainments. The levels attained through the *opus* manifest within alchemical dreams, related to the pathway, step, and state of one's being or daemon, communicated through a visionary language. The levels themselves will symbolically manifest through bird imagery, and most, if not all, traditional alchemical imagery will eventually manifest through both cycles of the *opus*. These manifest within highly resolute and realistic dreams occurring through these levels, including the Chymical Wedding.

The alchemical eagle belongs to a series of varying birds. These would include a hen, raven of the putrefaction, a bleeding pelican representing the vessel itself, pigeon, peacock, vulture, swan, dove, and eagle or the supernatural and eagle-like phoenix. Sometimes other birds are included, such as the ibis. A parrot is related to the peacock in Maier's *Septimana philosophica*.[2] These belong to phases

of the *opus* in which the egg in its possibility of rebirth or transformation occurs, as these birds represent the state of the vessel itself. Birds represent states of the soul within the *opus*; states of being, perspectival heights, and transformation. The state of albedo or whitening representing a purification generally follows the putrefaction; associated with a white bird, a dove, or a swan, and with the unicorn, and with the white rose or the lily. It is initially the purification of the putrefaction or blackening, and is sometimes represented as near or partial completion by a raven with a white head.

The seven steps do not necessarily follow one another in simple sequence. The sequencing is a kind of circular guide or schema. For example, the putrefaction continues after the alighting has been attained, so that the raven may appear late in the *opus*. There is, however, a certain level upon which one stands, which may be recognised.

Each phase is a kind of testing ground that precedes the next level. A key to the success of each phase is acquired by maintaining a deep determination or perseverance. The doors or gateways of the *opus* are opened by a key that unlocks the regions of their horizon. The key unlocks formations of a perspectival position, which is, in itself, always a deep and unconscious secret, that occurs by itself. That key is found through a perseverance that surmounts each phase. That region then structures the psyche's images through a visionary perception.

Each stage is also a maturation, which is either a disillusionment or a breaking of illusion, that attains a new ground or Illumination;

while this wheel develops its own momentum through the *opus*, and need only be followed with patience and persistent force and awareness. Once set into motion, the *opus* takes its own course, regardless of the thoughts, feelings, or wishes of the practitioner.

In practice the spiral of the phases of the *opus* appear as gradations, wherein the full circularity of the *opus* is present from its beginning, in a lesser form. All of the phases may then be experienced, psychically and viscerally, aesthetically, or to some lesser degree, from the beginning, not being mere imagination. The *opus* involves a mastering of one's light and illuminations, which means essentially to master a withdrawal and presencing from within oneself, as each phase contains its own perceptual abysses.

Noon, the practice of dreaming

The phases of the *opus* are set into motion through dreaming. It is only through *dreaming* that the psyche attains the visionary abilities required to withdraw from images and to create or discover images, in a fullness of manifestation that realises the *opus*. These experiences of light are brought into a practice through *dreaming*, in which the forces of a 'making appear' are acquired. The act of maintaining an apparent perception continuously occurs in reality, and the artist 'makes appear' through the forces of a work. And then, every person 'makes appear' within the psyche in imagination and in dreams. Here however, the concern lies with bodily forces of a bringing into perception through the psyche.

Dreaming is real, and has all of the qualities of reality, including its depth of space and movements in time. Its light is not in the mind, but emanates from the distance of an invisible sun, as does the light of our world. Alchemists often understood the sun as twofold, giving a hidden alchemical and ethereal level to the sun and its light of the world. They imagined an 'inner' invisible light, emanating from a darkness in some understandings, and an 'outer' visible light. The conception of this solar duality is thought to have origins in Empedocles. He envisioned two suns, one archetypal *(archetypos)* and one visible. The difference between the invisible sun of a true structural infinity, and a light of sun as a present sun of world, is encountered in *dreaming,* as the possibility of being within that difference, in which a mastering takes on its possibilities.

The initiation of *dreaming* practices requires at least six acts:

1 Unrelenting intentions set within oneself for an extended length of time, months at least.

2 A command given to oneself in a state of internal silence to do *dreaming,* with no interfering matters, or as if nothing else matters.

3 Viewing one's daily world for lengths of time as if in a dream, with no *a priori*, or as a kind of naïve vision, or as if looking at a random, foreign image. This should be done with full scenic vision, emphasising the entire span of one's visual world. Human beings tend to focus visually on a kind of circle of vision in front of the eyes, while everything surrounding tends to become de-emphasised as it recedes. Similarly *dreaming* can be like a tunnel vision, which should be countered through practice, and which eventually ceases to occur.

4 Acquiring the ability to raise consciousness within dreams, and say or think 'I am dreaming.' According to Castaneda this may include an awareness of the body by looking at one's hands.[3]

5 The forceful psychic stabilising and holding doggedly of individual dreams. This should be accomplished with the whole body, and not merely the mind.

6 Some conservation of energy. Castaneda refers to a requirement of sexual energy to do *dreaming*. But there is also a generalisation he seems to do wherein internal energy is referred to as 'sexual.' It seems satisfactory to understand that psychic energy in general is required for *dreaming*. The creation of the vision itself requires one's own energy, where in normal, everyday life that vision is already created, requiring less or no energy.

Along with these it is important to attain a certain serene interiority, and a general ability to maintain internal silence for lengths of time. This allows one to maintain and hold *dreaming* and individual dreams for extended lengths of time. It requires a looking away from the self, and a relation to death, and a feeling of death can offer the psyche a strength and serene intensity required. Death gives the psyche a "precious and fragrant drop of levity,"[4] as Nietzsche says.

Opportunities to do *dreaming* come about by themselves in dreams, and those moments do not come often in the beginning. *Dreaming* is then experienced as a serene, but often surreal, 'total' world. One's perspective and the invisible sun change their position, and the body enters a shadow world, of pseudos and apparitions.

Schopenhauer points to the ancients' "whole conception of the realm of shades" which "probably arose from spirit apparitions":

> . . . shades, *umbrae*, ειδωλα καμοντων—νεκυων αμενηνα καρηνα,[5] *manes* (from *manere*, remnants, vestiges, traces, so to speak), lingering echoes of departed phenomena of this appearance-world of ours which manifests itself in time and space, becomes perceivable to the dream-organ in rare cases during the state of wakefulness, more readily in sleep as mere dreams, but most easily, of course, in deep magnetic sleep when the dream therein has been raised to sleep-waking [*Schlafwachen*] and this is clairvoyance.[6]

The shadow is associated with the apparition, that becomes apparent and perceivable to a dream-organ. This shadow nature of dreams becomes as real as the 'real' world, and as that real world becomes itself a shadow. The surrounding dream world then acquires its own recurring momentum.

One is then open to persuasions which may disturb the continuum of *dreaming*, wherein one's serenity and strength of perspectival control are essential. What may interrupt *dreaming* then, when attempting to prolong and maintain it, is one's own human shadow's doubt, and its gravity. This doubt when it becomes heavy, will pull or necessitate one back into waking life, and which also occurs simply through a decrease of energy. The processes of purification of the peacock's egg are the casting off of a shadow, of the day's shadow, or the human shadow, as shadows change direction at noon, and the twilight or occult shadow appears.

Accomplishing *dreaming* is an awakening of the daemon and its ability to transfigure images within the psyche, and the assertion

of a structural basis there, as a bodily awareness. It is an experience of the powers of the perspectival psyche, as *dreaming* develops a strong intentionality and a perspectival independence. It assists in achieving the maturation of a solipsistic intentionality, and is accompanied by a new bodily formation and awareness. One's anatomical entity becomes serene, and the metaphysical body a double of light, and eventually a double of one's existence.

Invoking the putrefaction

The putrefaction is a blackening, eclipsing disruption and interruption in one's fate and continuation as oneself. The personal nature of the states of the putrefaction requires its own understanding, in that it differs intrinsically with individuals. This is so even in its requirement to be an issue, or to be something which requires seeking or finding. Its complexity and difficulty, however, are always an issue, within its undergoing, because its goal, which is an alighting, involves a focus on aspects of human nature which are always onerous. It is the undergoing of an upheaval, a reversal, a loosening of energy which reverses its direction through a turning, and an alchemical transition.

This blackening should be sought by the practitioner only after having accomplished extensive and excessive *dreaming*, for years possibly. In theory, excessive *dreaming* causes the human body to realise the illusion of its reality. The body becomes saturated with its own alighted experiences of other realities. This gives it an ability to awaken and attune the *lapis*, to enlighten and sensitise its presence, through a forced necessity. This may be understood as a merging

of corporeal and spirit bodies; which are of varying separated distances in persons, and in which the *lapis* is also always alighted to some degree.

At this stage the vessel is open, and the goal is to reconstitute the vessel by developing the *lapis*-tool that accesses the ethers. That tool alights through an opposition, or a juxtaposition, that causes this alighting of the *lapis* through an enforced doubt within the soul, and falsification of the self, or persona. It is externally imposed on the practitioner, and met with a difficult and perspectivally strengthening balance and asceticism. And as with *dreaming*, its opportunity comes about by itself as the practitioner reaches its level.

The putrefaction has a parallel in Castaneda's work through an approach he calls "stalking" and dealing with "petty tyrants." Stalking is an extensive, prescriptive outline for behaviour the practitioner adopts for being in the world and dealing with people. It has deep intentions regarding self-control and internal effects. It has a general form adopted within behaviour, and a more serious and dangerous form utilised to cause profound change. This more serious form is parallel or similar to the alchemical putrefaction because it involves and forces a deep change in the practitioner. And then this change is an undergoing of a loss of something he calls self-importance, which has a "limitless capacity" based in "foreign filaments" of light,[7] but which is not explicitly defined by him. Castaneda's recapitulation process, which is parallel to the breathing processes described here, utilising the peacock's egg, is also a part of this behavioural practice. And these then coincide with and enhance *dreaming* practices.

The specific intentions of the putrefaction involve a blackening that forces an internal change, and an alighting, which can involve a serious and dangerous game. External forces bring about an encompassing doubt that is surmounted. A heavy, unbearable weight or pressure, here associated with the pressure of an amber ether, is overcome. Its darkness is associated here with distortion, exaggeration, and the aspects of human shadow. The shadow is encountered and entered, in its overstatements, its understatements, and in its augmented and heavy, and subtle and slight distortions. It is entered through its tragic and comic natures. The blacker the more effective, in some cases perhaps, if it can be endured, as the psyche transforms through a blackness that turns the serpent's poisons. For Zarathustra the putrefaction is depicted as a black serpent that enters a shepherd's mouth and bites him there, who in turn bites its head off and expels it. This metaphorises the vessel as it is open and putrefied, as in the gaping mouth depicted in a 17th century image by Goosen van Vreeswijk,[8] and to the ingestion and digestion of human energy. The practitioner suffers a form of nemesis, as the shadow's estrangement invokes an oppression, that can force the psyche onto a path of light.

Twilight death, and midnight

The experience of a symbolic death occurs of itself, as a death-moment. Unexpectedly, the spirit detaches from the body in a highly resolute manner. This will occur during the purification, and most likely while resting or sleeping. It will be accompanied by symbolic or meaningful imagery. The spirit will detach from the body, while perception remains at the place where one is in the world, and

then reunite with the body. This experience is shown in the *Rosarium philosophorum*.[9] It is also described by Castaneda.[10] It is a marker, an acknowledgement of the body's state as primarily spirit. From this point onward the psyche has a visionary nature, and *dreaming* and visionary experience will necessarily occur.

The appearance of evening twilight is the onset of the timeless-time of the occult or twilight shadow, and of the structural ground of the psyche. The shadow appears between the apex abyss of presence, or noon, and the abyss of withdrawal, or midnight; time and space have these as their necessary opposition of appearances, within these phases of the work, and the shadow's horizontal ground. The daemon is revealed as is the archetypal and alchemical image, and invisible or archetypal sun, as Illumination of this Infinite. Twilight is the space and time of an occultation and its psychical apparatus. It is an absolute, that exists between the ethereal world and the apparent world with its own Illuminated ground that excludes and yet holds those worlds. It is an absurdity, but is at the same time the very rational *techné*.[11] of the world. And so it is the occultist's world, that holds a difference and distinction from other moments. It contains its own differential void, wherein black void meets black void, as it does not yet exist.

A purification of light allows for the *opus* to be attained in its most powerful form. Through this purity, midnight, as the most darkly abyssal phase of light, and the place of an abyssal path, gathers and constellates the light of the psyche. Midnight is the time and place of the light of the peacock's egg and its constellation, or *logos*.[12] The perspectival, invisible sun changes its position as its illumination reforms.

Through the *opus* a new centrality of the psyche is acquired, as it follows a pathway to its magnanimity, and supersession of human paths. A practitioner's profound attainment occurs when the spirit or daemon takes on a primary place, and a perspectival stance is assumed under the invisible sun, as its occult position. It contains, perhaps, a frightening emotional death, and absence of measurement, and self-reflection, but which all becomes reconstituted. It is a relocation and centring onto an alighted-dead ground wherein the self is reconstituted. The practitioner attains a potency and potentiality, as the serene, elevated mortal, and what the Greeks called the *phronimos*.[13] He is the mortal because he has realised death, and does not perceive or interpret through immortal Ideas, but through the *techné*, or art, and Illuminations of alchemical structure. This new light is silenced of its immortal forms of lighting, it Illuminates within its death as Illumination itself.

DAWN AND LAPIS

The final phase of the *opus*, its dawn, is the attainment of its goal, and alighting of the *lapis*.

The attainment of the initial alighting gives access to the ethereal energy. The attainment of the will gives access to the *logos*, or the perspectival positioning. Human being is, in an essential way, for the alchemist, a flower-like, luminous egg, that also has an amber, perspectival nature. To awaken the *lapis* in the first cycle means that this luminosity may be mastered, and sealed, and is no longer prone to suffer permanent affects or damage, as the wheel flows clearly or freely. And to awaken the *lapis* in the second cycle means

that the perspectival nature of this luminosity may be mastered, and is no longer fixed or constrained, as the wheel or *opus* is also mastered.

The early Greeks had an understanding of the phrenic impulse, which they called *thumos*. David Wiles describes the midriff area of the body as it related to Greek tragedy:

> In the world of Greek tragedy, thinking is indisseverable from feeling. Mental sensation is associated with a series of different terms, all of which have a more or less precise physical location in the central region of the body: *cholos* (bile), *phrên* or *phrenes* (usually translated as 'mind' and loosely associated with the diaphragm), *kardia* (heart), *thumos* (notoriously untranslatable, conceived in liquid terms, sometimes rendered as 'will,' 'impulse'), *hêpar* (liver), and the generic term covering all of these, *splancha* (innards).[14]

In tragic theatre the central altar, or *thumele*, was located at the *omphalos*, or navel-stone. In relation to the body the "navel at the centre of the body was seen as a kind of root from which new life stems."[15] And the alchemists related this centre to the *lapis*, and called it the *omphalos*. The liver *(hêpar)* was an important occult area for the Greeks, used in divination. And for Manly P. Hall the spleen is the "gateway to the etheric body."[16]

The will as *lapis* may be seen as metaphorised in a drawing of Leonardo da Vinci's, *Allegory of Navigation*, also called *Allegory with Wolf and Eagle*. It depicts a difference, and place of this difference, behind the image, or between the psyche's images; and between wheel and perspective, within a boat wherein the helm is perspectival. This boat represents the alchemical vessel, and the

olive tree is the Sephiroth tree, through which the mercurial wind blows. This image may be seen to convey the differential and abstruse place of the alchemical will.

Leonardo da Vinci, *Allegory of Navigation*, 1517-18.

It is perhaps not possible to define exactly with words the serene,[17] coloured states of the encasement of this peacock's egg. But their purest, highest, and most serene states may be approached with some definition nevertheless. All of the following states contain an essence of purity and serenity in their definitions, to distinguish them from other colours:

~ The *grey* is a matter-of-fact equanimity, or indifference.

~ The *black* is a knowing, and an unknowable abyss.

~ The *violet* is psychical force.

~ The *turquoise* is a holding true or carrying-with.

~ The *forest green* is a deep and sound, or earthly equanimity.

~ The *cobalt blue* is an affirmation, or a ringing true.

~ The *mars red* is a boldness or strong movement in time and space.

~ The *lustrous brown* is an emotional fullness.

~ The *rosy pink* is a lightness or a detachment, that is also vibrant.

~ The *bright silver* is the mercurial quintessence of an unhindered striving.

~ The *copper* is a warmth of contending.

~ The *clear* is an intensity and clarity.

~ The *gold* is an ascent or victory.

~ The *white* is an attention.

~ The *amber* is a justice or justification, or balancing. It is also contending agreement.

This is not to say that these are the only serene colours, per se, as this is not a definition of colour, but of this anatomy.

These states all have opposites or degraded forms then. For example, gold is defined here, in its serene or superior state, as ascent, which, as other various forms of yellow would be distorted or degraded ascent. White as pure attention has distorted or degraded forms through its mixtures. Black has purity as a depth of all colour in itself, and therefore of no colour in some sense, but which also contains distortions through its emphasis of colour.

Virtue, for Zarathustra, is a "nameless" bird that sits on golden eggs,[18] and virtues are "coloured sea-shells."[19] These states are the

basis of virtues, or they may be considered as virtues themselves. All of these encasement colours and energies are a kind of willing force then—as the psyche's pathos. They are not a 'will' or intentionality in itself, they are states of serenity, fecundity, freedom, mastery, etc., that belong to the atmosphere of the alchemical will.

The essential nature of these states is temporal. Their light has a temporal basis, as it is present and inclines toward past and future, and as coloured light is essentially temporal vibration, through its intrinsic repetitions. The serene state of colour then fulfils time, without dissipation of the self and time. They are also a patience since they do not negate time. And they are the most solitary wilful states, and the achievement of the will's solitude in its time, and its solipsistic domain.

The willing forces of this anatomy may be seen as follows:

A) Light seated in past affects and in others' impulses or forces.

B) Fate and its momentum.

C) The intentional impulse.

D) Will and transition of path.

The psyche's movements, as movement through its paths, and illuminations, are fluidly based in these four possible forces, which exist as influence to varying degrees, at differing moments. These are the forces behind the psyche's strivings and fateful perceptions.

A, through the purification process, is reduced to something that is not forceful or cumbersome. B is the psyche's fateful path, or circular path, in the entirety of its imagistic and perceptual life; including all degrees of extension, from imagination and dreams to the physical body and its world. C is the intentional impulse, as authentic intentionality, while D is a more profound intentionality, or will.

In this sense, while A, B, and C can influence striving or fate to varying degrees, D may occur intermittently. D is profound intentionality, an originary or deep *logos*, and an occult will, and is the basis of the initiation of *dreaming*, while the intentional impulse C is always limited. Will as transition of path (D) is a transcendental moment that overwhelms these all (A, B, and C), and supersedes limits. And that limit is the limited realm of the whole *opus* or wheel, limited by its momentary force and power.

The doubt referred to here then is not a lack of belief, which is something that takes place merely in the mind or feelings, and is not a lack of 'self-assertion,' which is often itself based on a doubt.

It is an impeding or veiling of the occult will, a lapsing, or a degradation of the *opus*.

With Castaneda the will is an extraordinary, paranormal force centred in the midriff. It is both a potentially effective, and even prehensile, force that extends into space, or an infinite occult space, and a force that potentially alters fate and the perspectival position of perception, it is the 'assemblage point,' and "the power to select, to assemble."[20] The original manifestation of will in the body is preceded for him by a silent blackness, or by physical convulsions he says, prior to which the body must be a 'perfection.' And he places importance on the completeness of the egg-shell, and fullness of the amber substance.

The alchemical will follows the Chymical Wedding. For Nietzsche this is the wedding of the Dionysian daemon and the Ariadne vessel-encasement. It is a time when the central phrenic area of the ethereal body gains victory, and the vessel is made whole and is closed, and the amber light is renewed. It is the realisation of a divine love, and the communion of above and below, and of a laughter. It manifest as a dream in which the *dreaming* body attends a wedding, or as some similar imagery.

The will manifests and occurs following a thorough or profound purification of the anatomy. It becomes accessible with the purification, and belongs to the dove's egg. It perhaps has parallel in the Buddhist conception of will, or perhaps in the will, or 'true will' of Crowlean Thelema. For Nietzsche the will, or will to power, is something unfelt, where most conceptions of the will are referring to a reified, after-effect of a hidden or true will. Its emergence

precedes a dawn, while for Zarathustra it is the overman's Illuminative "sun-will."[21] The whole *opus* acquires a fulfilled level; while access to will, or the deepest *logos*, may be found within a dispassion, or an *apatheia*,[22] as the wheel slows its movement, stops.

In the garden

An alchemical allegory may be made for the practitioner's attainments.

> *The serpent is pathos, and therefore everything that is, or the act itself. It manifests as a dragon because the natural world itself is, in its coldest fact, a supernatural being. This being is apprehended and mastered through the practitioner's art.*

> *When the lion laughs it dissolves a sun and subdues that being, or when the lion laughs it creates a sun, and alights that being. Between those laughs is the eagle's perspectival freedom. And between those laughs the serpent is mastered.*

> *The walled garden is the practitioner's sanctuary, existing beyond the sun's blackening. Within the garden is the mercurial fountain, as life's source of the abundant will. And within the garden are the apparatus of the practitioner's art.*

> *The garden may contain two kings who hold a spherical mirror, reflecting the practitioner's images.*

The dragon is a magical being, appearing in alchemical texts throughout alchemy's history. It is the serpent combined with the eagle and the lion, and is sometimes depicted as such. Its name originates from the Greek *drakôn*, which can refer to this supernatural serpent, or to a sea-serpent, or a large serpent. '*Drakôn*'

is thought to derive from *drakein*, meaning 'to see clearly,' and *derkonai*, meaning to see or look, as a flash or gleam. Its name either refers to that which sees or looks, or that which shimmers or reflects, or to all of these aspects or apprehensions of light. The serpent, which also has a mercurial basis, moves through transformations in alchemy, from snake to dragon, and also takes on a circularity, often depicted in circular forms. It stands for *Aiôn*, or a world, as it encompasses land, air, and sea.

The dragon is subdued or transformed, and becomes the lizard or salamander, as the salamander appears within the *opus*, and lives in the alchemical fire. Theosophist and occultist Franz Hartmann describes an internal alighting in terms of the Salamander.

> The spiritual "fire" is awakened within him, he attains the spiritual powers required to act upon the inferior elements. An insufficient degree of heat will not accomplish anything great. He must gradually attain within himself the fire of divine love until he becomes himself the Salamander, able to live in a light in which nothing impure can exist.[23]

The salamander lives in the pure alchemical fire, as Maier also depicts.[24] Similarly, the dragon, and then a lizard appears in Nietzshce's *Thus Spoke Zarathustra*, a gentle, lightness of the glance or look. And the lizard is equated with the salamander in *The Book of Lambspring*.[25]

This moment, of subduing, dissolving, overcoming, conquering, etc., contains then the laughter of the lion. The green lion dissolves or devours the sun in the *Rosarium philosophorum*. The lion's dissolving laughter is the heavenly dew; a type of chymical, vitriolic dissolving

agent, which obscures the measuring forces of a sun's illusions. The alchemical vitriol is connected to the *lapis*, because the purified vitriol reacts with metals other than gold, through the transformative *opus*, dissolving the impurities of the gold, or sun. The heavenly dew, in Latin *'ros,'* falls in the rose garden. The garden is, in its spatiality and imagery, a metaphorising of a natural sanctuary, as earthly transcendence. In its fullness of imagery it metaphorises the whole, alchemical self. It has Judeo-Christian significance as the Garden of Eden, gardens in the Song of Songs, and as the Garden of Gesthsemane. The enclosed garden, or *hortus conclusus*, is also seen as an allegory of the Virgin Mary. And the alchemical garden appears often in *Thus Spoke Zarathustra*, a garden of "roses, and bees, and flocks of doves!"[26] including allegories of two kings and mirror, and garden with laughing lions, eagle, and serpent.[27] The "heavenly tears and dew showers" fall into the "hanging rose-garden" in Zarathustra's 'Song of Melancholy.'[28] The gold lion is then the alighting of a sun, or world, of the *lapis*, or of practitioner's will. The gold lion is the will of dawn and its horizon, as the *opus* is circular and returns eternally.

The alchemical process as a whole may also be seen as an *imitatio Christi*; as the shadow imitates; the putrefaction being understood through the Passion. And then the purification, understood as a casting off of the shadow, is such, as Christ, according to the Gnostic view, cast off the shadow he was born with.[29] The vessel may be interpreted as represented by the Grail, or the Eucharist Chalice, and then the *opus* has parallels through an etherisation of the Blood. The Latin INRI, sometimes placed on the Crucifixion, also has been given an alchemical meaning, as *Igne Natura Renovatur Integra*. 'Through fire nature is reborn whole.' This is accentuated

by egg symbolism, appearing in Christian art, such as Piero della Francesca's *Madonna of the Egg*. The peacock's egg is also mentioned by the Christian Gnostic Basilides, with 365 colours.[30] The *opus* is generally thought to ascend then to the Holy Ghost. And the process also has parallel in Jewish mysticism through the *Tsaddik*, who undergoes a type of descent and ascent.

The mercurial fountain in the garden refers to the alchemical *prima materia*, or the alchemical light or energy itself. Jung refers to the *aqua mercurialis* as characterised as the "bright and clear fluid of Bacchus."[31] He notes that this substance had no less than 50 synonyms, and is the basis of the *opus*:

> The basis of the *opus*, the *prima materia*, is one of the most famous secrets of alchemy. This is hardly surprising, since it represents the unknown substance that carries the projection of the autonomous psychic content.[32]

It is the substance of the dew, the serpent, and the spherical mirror, and is the essence of the *opus*, since it is the mercurial light or quicksilver that moves through the various elements of the alchemical process.

The king is parallel to the lion, as the justified position, and its power and dominion or realm. It is the wilful position of the practitioner's perspective and its illumination and domain. The two kings are a silent, caesuraed self, open for images, which appear of themselves. The spherical mirror is reflection within the psyche, as it encompasses the full realm of the psyche, as in Trismosin's *Splendor Solis*.[33] It is reflective light and its nature as perception, alighted through the *opus*—as the garden flourishes in its sunlight.

VI

Dreams

During the realisation of this anatomy I experienced *dreaming* related to its appearances and structure, and to the Phases of the Opus and the content of this whole understanding in general. Here are described some Jungian types of dreams, of alchemical and archetypal nature, related in various ways to this metaphysical anatomy. They may best be seen to represent a recognition of moments of the *opus*. This section will also give the practitioner some idea of what they might experience, which will vary with the individual and perhaps their background and temperament. There is an abstract basis or schema to this imagery, which manifests as the practitioner traverses a path.

The later stages of the purification were accompanied by strong alterations of perception, and an ease of acquiring internal silence and doing *dreaming*. It is true, or seems to be from what I've gathered, that a lot of people have accomplished *dreaming* because of Castaneda's work. 'Lucid dreaming' is not what is referred to here exactly, however, since this *dreaming* involves the actual physical constitution of a perceptual world through all of the senses. Ordinary dreams, and lucid dreams, become very real and even visually objective and other-worldly, and lengthy and continuous, however, within this attainment of *dreaming*. When *dreaming* actually happens there's an obviously resolute, physical experience, and an enforcement of consciousness. And obviously, when dreams become 'real' in this way certain things go with that, because they become nearly full experiences.

I was able to distinguish four types of *dreaming*: those dreams in which I found myself in some seemingly meaningless, realistic place or vicinity; those in which I found myself consciously in my flat in a *dreaming* state; short meaningful scenarios which were lucid, objective dreams or *dreaming*; and single, still images or visions that appeared in my room by abruptly interrupting sleep, or a dream, seemingly causing me to wake. All of this imagery manifests with the highest degree of objectivity and clarity. And these four types of dreams do combine and merge.

The first type are perhaps the strangest. They last longer than the other types, as their duration is not related to some meaning or alchemical message. They are experiences like being in our own world that simply go on for some length of time. Some of the most enjoyable of these *dreaming* experiences I had occurred early on, while I still lived in America, prior to working on this text. I would find myself in some vicinity, usually suburban areas of a city, or some landscape, where I simply attempted to extend the dream for as long as possible, usually by doing something like walking; something wherein my equilibrium would not be disturbed. I used these dreams to gain control over my body and its movements in *dreaming*. And sometimes I would perform actions that I had planned prior to sleeping, but which is difficult because of the memory required. In any case, this type of *dreaming* is often enjoyable and serene. And sometimes they last for seemingly a half-hour or more. In fact, there were times when I became concerned that I was spending too much time in *dreaming*, and deliberately woke up. In one case I was unable to wake, and just continued what I was doing, talking to a woman I met and some other people, until I seemed to have run out of the psychic energy *dreaming* requires,

and woke. Prior to undergoing the purification praxis described here this type of *dreaming* occurred, on average, only once every two or three months, at best, on occasion sooner, but more often later. As this purification process went on these became more lengthy and involved, and I had these experiences weekly, sometimes daily, and regularly.

The second type, which occur within the immediate vicinity of where one is sleeping, are like so-called 'out-of-body' experiences. They started in the beginning, along with the initial *dreaming* practices. Even before I had my first *dreaming* experience, I once woke from sleep with my arm, a blue spirit-like hand and arm, separated from my body. But later, with the purification, they occurred as a seemingly fully awake state, wherein it often took some time before I realised I was in a dreaming state. I would see something, or find something, in my flat that was not there before, or was not possible, and then be startled, sometimes horrified, into realising I was not awake.

The third type are most often alchemical dreams, in the terms Jung discusses. They generally occur as a short series of events or images. For myself, there were two striking elements to them: They always only seem to last for as long as is required for their imagery to start and complete, and not an instant longer, and they do not seem to occur for the benefit of conscious memory, enjoyment, or understanding. They begin and end instantaneously and seem to occur as some kind of necessity apart from oneself. These dreams come with a liquidy clarity, though they can also merge with the other types of *dreaming* described here.

The fourth type involve, sometimes frightful, images that appear between sleep and waking. Through *dreaming* practices moments begin to manifest between one's sleep and time of being awake, that often include imagery.

There is a further aspect to *dreaming*, which belongs to the first type of *dreaming*, which I thought of as hard *dreaming*. This occurs when the place one is at in *dreaming* is so real that it is literally like entering a real, cold reality, where one can feel the atmosphere and hear subtle sounds. Here objects are absolutely solid, and there is nothing particularly disturbing or exciting. It is almost like an alone boredom, as if being thrown into a stone-cold, sober morning. Consciousness is also total in these *dreams*.

There is usually a problem with this dream consciousness however, and with all of these types of dreams, as the memory one has then of one's life and self is sometimes limited, which is comparable to the way dreams are difficult to remember in waking life. This kind of memory is a further faculty that has to be developed, along with consciousness.

There is also a further type of *dreaming* that requires its own analysis and explanations. It involves the visitation of what seem to be genuine other worlds—seem to be, I'll say here, without asserting this, since this requires explanation. They occurred more often as time went on, and usually involved what seemed to be real cities and human beings, foreign to my own self or memory. They seemed to be as free of psychological content, in terms of dream analysis, as our world is. And an issue arises regarding the existence of energy or structure within things or beings, because these can have real

effects. What these dreams actually were remains an unsolved riddle for myself. But these are not described here, and will be in another work.

Most of what follows are descriptions of the second, third, and fourth type.

The moment I referred to as a symbolic death moment in chapter V occurred for me early within this purification praxis. I simply woke in bed and rose up and hung floating in the air across the room for several moments. It was accompanied by several real appearing moths that clustered together and flew onto my hand prior to this detachment from or spiritualising of the body. What seemed most significant about this experience was its resolute nature, which was also somewhat frightening. Its physicality was highly resolute, or congealed, as compared to the common 'out-of-body' experience, or other similar experiences I also had, and had afterward as well, that are less physical.

There is an important aspect to the expulsions that takes on a visionary nature, though somewhat mundane in its imagery. This is the repeated dream or hallucination of the spider or of a worm, which may perhaps be associated with the alchemical garden. These spiders were often extremely vivid and real appearing images, projected into my room, or within dreams, often when I dozed off for a short time. Their importance lies in the fact that they are always accompanied by expulsions from the anatomy of a mysterious energy, that is often watery and seemingly acidic. And the worm has a similar nature. The worm also relates to the alchemical death, as once I woke and saw that one of my legs was

filled with worms. The spiders were often colourful or grotesque, and always appeared as something new or different than those prior. They also appeared in meaningful contexts, for example one appeared within the centre of a red rose, and a tarantula appeared dead, on its back, on my nightstand, accompanied by funerary music. They belong to the abysmal depths of the putrefaction, and ceased to occur with time.

Another somewhat mundane but important issue is that the masses of energy, as they are intaken or as they move within the encasement, manifest in dreams generally as wild animals or sea mammals. And so one can expect these to appear often during the praxis. For Jung wild animals "indicate latent affects" in dreams,[1] which may also be appropriate to this interpretation.

But then the alchemical animal also appears. The lion appeared many times, often very real looking, and sometimes varying in colour, such as black or silver. And the mercurial serpent takes on its place in this dream process, manifesting as the lizard, snake, and as the dragon. For myself the dragon appeared in a mountainous desert, and strikingly real, as it flew in the air and then sat on the sand and rocks.

In my case the alchemical dreams included religious imagery, which was not related to personal beliefs or feelings. At one point I dreamt I was at the Last Supper just as it had ended, and I also woke in bed holding an amber stone beaded rosary. But the most memorable of these was what seemed to be an authentic baptism by the Archangel Raphael. He twirled out of a wooden bottle I found in my flat, while in a *dreaming* state, which had a black crucifix and

rose on it, with geometric top, an octagon I believe. He appeared standing then with white wings, and wearing dark green and a white garment, something like a satin doublet, adorned with red roses; a sublime and beautiful being, with dark hair, and somewhat small of frame. And another angel who also appeared, and introduced the first being as Rabbi Raphael, which simply means Master Raphael, sprinkled water on me three times from a tea maker I had sitting there.

As mentioned in chapter V birds are a significant manifestation through the *opus*. They represent the various states of the psyche as it proceeds through the *opus*. For myself these manifested as a pigeon, a wild hen in a forest area, a raven, pelican, the peacock, a seagull, a white dove, falcon, a white eagle, and a coloured eagle owl. The phoenix appeared, born from an egg, with spectral coloured wings. And a hummingbird appeared taking nectar from a flower in a room I was sitting in, in *dreaming*. The peacock always appeared as a miniature bird. The raven once landed hard on my left shoulder, and I shrugged it off and it jumped to the ground.

The alchemical dreams manifest as complex scenarios, as they become interesting, and of the kind Jung discusses. And the putrefaction as blackening and as shadow, manifests in these dreams, in various ways, sometimes in hidden ways.

An example of this occurred for me as a three phase dream, which is a typical structure to these scenarios. While walking along a street, three images manifested: a double-horned black 'unicorn,' across the street, that approached, bowed, and reared, followed by a human-sized monkey, standing in the middle of the street, with a

large, brown leaf over its head, followed by a bird, perhaps a pigeon, that flew up to me and hovered still while it laid a heavy, hard-boiled egg in my hand, which I cracked open and took a bite of. There is a shadow nature to this dark imagery, while both the unicorn and the monkey or gibbon, are images with varying interpretations, discussed by Jung.

The putrefaction is represented by a black marsh or swamp in Trismosin's *Splendor Solis*, which also manifested in my dreams, along with the putrefied Rebis. It appeared as a black-violet human octopus near the swamp, that stood on its eight legs, and then on two human legs as it talked and changed from male to female. It had attempted to penetrate a white vessel that was there, and failed, and then descended into the swamp.

The *lapis* or stone manifests as it is approached and alighted. At one point I saw a large toad in a garden, sitting under an elevated stone, in its shadow. But Jung discusses diamonds as representing the *lapis*, the "treasure hard to attain." They reflect the colours of the rainbow. The *lapis* is the vessel's internal alighting. Jung: "As the Grail is the life-giving vessel itself, so the stone is the *elixir vitæ*."[2] And to bring the *lapis* to the King is the completion of the *opus*. In my dreams I brought several black bags of diamonds to a King, sitting in a throne on a street. They were ¾ to around 1 inch square, clear shards, which I set in front of him. I connected this dream to the first cycle of the alighting, because of the shape of the shards.

The King and Queen are important manifestations in alchemical dreams. At one point I decided to dream of being in a garden. I slept and dreamt that someone opened a door that lead outside of

a house I was in. The person appeared to be a silhouette of myself that stood outside of the doorway. Then in a following dream I was in a garden and there was the Queen, sitting with a small amber ribbon and some red flowers tied to the back of her short, curly black hair. After talking with her for a moment about her ribbons, and, as I remember, eating an apple, I suddenly woke and sat up in my room laughing joyfully, but then I looked around and realised I wasn't awake. I had to wake again.

The male and female aspects of the Rebis, and of the King and Queen, have meaning in terms of the vessel. This is difficult to define exactly, because it varies with these images and levels, but in general one may say that the male represents the mastery of the vessel, while the female represents the vessel itself. And then the Chymical Wedding occurs as these are purified and joined. For myself this was anticipated as my attendance at an elaborate wedding in a cathedral. Everyone was waiting to see the bride. And then later as the dancing and laughter of a couple.

But there is also an occult duality of the self that occurs, a kind of movement and reconstitution of ones figure and shadow. At one point I dreamt there were two of me awake, and we greeted each other in warm friendship. Scholem notes that, "were the *tselem* to emerge and become visible to the person, he would experience a kind of *Doppelgänger* phenomenon in which he encounters himself in an occult manner."[3]

Many other alchemical and occult dreams occurred for myself, and they continue on as the *opus* continues and its momentum recurs. And the Grim Reaper came to visit me, as he shook me with his skeletal hands, and woke me from sleep.

AN APPENDIX ON MEDICINE

The existence of this alchemical egg may be understood through field theories in modern and contemporary science, and through the spatial and temporal understandings of Albert Einstein. These scientific perceptions, when asserted in particular ways that allow for an occult chemistry to exist, may be seen as conducive to the understanding presented here. It requires that there be a type of relative ethereal field there. The spatial and temporal understandings of Heidegger may also be associated with this peacock's egg, as an invisible lighting exists existentially in space.

Here is presented an occult chemistry that perceives particular visual interpretations of radiation, and of human disease.

All natural light and electric light contain their own spectral invisible, coloured light.

Spectrums are given here regarding the invisible nature of physical light, both sunlight and electric light. These always contain a full spectrum, intrinsic to the light itself, which does not vary by what is seen by the eye. The sunlight may be understood as essentially black in its nature. And these invisible substances may be expelled from all areas of the human anatomy.

Sunlight radiation is black, blue and violet mixed, a range of green, thin flattened red, orange, a clear dark orange, thin flattened yellow, and vaporous or airy white.

Sunlight radiation:

Black	Mixed Blue & Violet	Full Range of Green	Thin Red	Orange	Clear Dark Orange	Thin Yellow	Vapor- ous, Airy White

Electric light is black, deep blue, a glowing light blue, a slight pink or violet to pink, a slight silver, metallic red, thin flattened red, lime green, thin flattened yellow, orangeyellow, and white. These electric light substances are always experienced as a light, smooth flowing energy when they are expelled.

Electric light radiation:

Black	Deep Blue	Glowing Light Blue	Slight Pink or Violet to Pink	Slight Silver	Metallic Red	Thin Red	Lime Green	Thin Yellow	Orange- Yellow	White

These ethers may be visualised and expelled just as human energy may be expelled.

The colours of foreign energy may differ from those presented here as human, sometimes involving a texture, or a gradation or complexity of colour that differs. They will often feel foreign and unhealthy as they are expelled. In any case this colour aspect always exists, and can generally be discovered through an intentionality that finds resitances within the body.

It is beneficial to cleanse the whole body through this idea, with the intention to access energy that is not human energy. As with human energy, knowing its appearance and consistency allows for a more direct and powerful access to it. And the expulsion methods used are then the same as is used for human energy. Often these foreign types of light enter the physical body and vortices, but they will also be based anywhere within the anatomy, including the encasement. In general, foreign chemicals have to be discovered by the practitioner through resitances that are detected.

Another detrimental type of energy that can accumulate in the body and encasement is radiation from computers. Its range of energy is almost as expansive as that of human energy, and the substances have similar weight, though also slightly foreign in feeling. Working on a computer will draw in potentially large quantities of radiation, which is enhanced by the current excess of technology, because psychological focus on information accomplishes this at an accelerated rate, and can also draw this energy deep into the body, into the internal organs and bones, it seems.

There are listed here 198 types of energy involved in radiation from computers:

Computer radiation:

	Black	Violet	Blue	Light Green	Red	Orange	Yellow	White	Pink	Grey	Clear	Silver
Colour												
Deep colour											■	
Colour's yellow tint	■						■				■	
Colour's white tint	■							■			■	
Black plus colour	■							■			■	
White plus colour	■						■	■			■	
Grey plus colour							■		■	■		
Crystallised colour												
Vaporous colour												
Silver plus colour											■	■
Colour plus silver												■
Thin flattened colour												
Clear plus colour											■	
Colourness												
Blackness plus colourness	■							■				
Whiteness plus colourness	■							■				
Greyness plus colourness										■		
Silverness plus colourness												■
Clearness plus colourness											■	

Each type will exist individually and may be expelled from any area of the anatomy. And as with human energy this light can exist in an attached state, where energy actually remains extended from the machine, in which case the machine has to be remembered, or imagined and fanned over. Masses of this radiation, like all types of radiation, can be detrimental, effecting the internal organs for example, and energy will be retrieved from within one's own encasement following expulsions.

This human anatomy is also the recipient of human illness and diseases. And a concern here involves a shamanic understanding of disease as metaphysical intrusion.

Walter Otto notes that the Greeks believed "the dangerous and the perilous clung to a man's being as an external defilement and could be removed by a very simple expedient." For this reason the *pharmakos* was led around the city to absorb every miasma.[1] American Indian shamanism contains similar understandings to the Greek miasmatic theory, noted by writer and early Native American anthropologist John Bourke:

> The American Indian's theory of disease is the theory of
> the Chaldean, the Assyrian, the Hebrew, the Greek, the
> Roman—all bodily disorders and ailments are attributed
> to the maleficence of spirits who must be expelled or
> placated.[2]

And then a contemporary understanding of this theory may be made.

Certain illnesses possess movements to their intrusions into the body; involving their contact with the body, their establishment,

and their onset and point at which the body may no longer be resistant to them. These movements are understood here by including a metaphysical intrusion. Viruses, such as influenza, are composed of singular metaphysical structures of energy, which function by affecting the surface of the encasement and by affecting the body and light within the body.

These structures manifest in some way, in degrees it seems, as the basic force and unification of the illness, without which the disease has no real power over the body. The presence, weight, force, and light-force of these structures are then the main and essential cause of their related illness. And this invisible structure is always a single entity having a consistent formation.

Similar to the understandings of Vitalism perhaps, this returns to the miasmatic theory of disease. The miasmatic theory of disease was refuted and replaced by the germ theory, through the germ theory is thought here to be incomplete without a metaphysical understanding, as is presented here. Physical science is always able to explain things entirely because everything that occurs Mercurially has a physical manifestation or effect that appears within a justified reasoning or schema, which then becomes subjected through language. That justified or perspectival schema is circular for Nietzsche, and arises through an imagistic abyss, that may be called Mnemosune, after the Greek goddess of memory.

The size of these structures in relation to the human body and encasement should not be understood as a relation to them as an organism. Nothing has its own measurable size within the infinity

described here, in terms of size or hierarchies of life forms, their size would be determined by a human perspectivism, as that is where measurement takes place.

What follows are illustrations of influenza and the common cold, and the accompanying fever, which is a separate structure. These are not beings with a mentality. Their consistency feels something like soft vegetation or dissolvable jellyfish when they are being dissipated. The structure always manifests at the frontal, phrenic area. Then the body's light reacts to their intrusions, and this reaction is the problem of illness, which manifests on a secondary level as physical and visible. They affect the body through their presence, particularly on the encasement, and through excretions from within forms or vesicles. The germs perceived by physical science are then thought to be related to these excretions, which have or acquire an independent existence. This structural aspect might then explain a difference between contact and onset of the illness in the physical body.

The expulsion of these structures is an experience of recovery unlike that experienced through chemical treatments. They are felt expelling, piece by piece, and there is sometimes a residue, and their quantities of energy are generally large. The removal of the structures usually involves a large quantity of energy, and the length of time it takes depends on how set in it is. They seem to either push off the encasement or curl in on themselves and expel from there. And the expulsion of these structures are always the clear experience of a large mass of energy.

Influenza seems to be an extended version of the common cold, or it might be that a portion of the illustration shown belongs only to colds. And some of the extensions or vesicles seem to remain dormant, or are secondary, noted with an asterisk.

The best way to expel the structures is to focus on them piece by piece, concentrating on one area at a time, and focusing on the centres and roots of the various areas. The most important expulsion is that of the structure, which includes a kind of defeat of the illness. Following this it feels as if one is just getting over the illness. And symptoms will linger in the body until all of the excretions are expelled. If, however, the structure is expelled when it first appears the illness will be dissipated entirely at that time. And with persistence all symptoms may be completely removed. Both influenza and its accompanying fever may be expelled at a time of their full-blown states in three or four hours.

Influenza and the common cold (Shown on page 195)

1. Large white slightly transparent area with slightly blue protuberances.

2. Large clear-white area with a violet lining.

3. Brown-red bar with an orange vesicle extending into the head. This is a bright orange which also yellows, and reddens in the

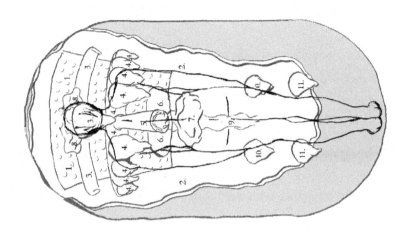

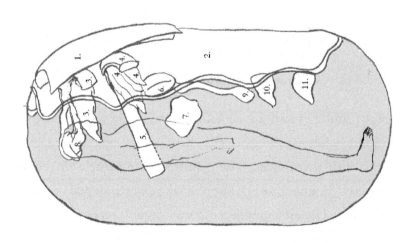

interior. It has a silver core that mixes with the three colours also. These all secrete into the head and down into the chest. They can also exist as a kind of intense, hardened energy.

4. Red-brown bar with four vesicles on each side, from the centre moving out black, dark red,* dark green,* dark grey.*

5. Gold or yellow metallic cylinderical protrusion into the chest, with red ends, and a dark green core.

6. Violet area in front of the sternum.

7. Green mist.

8. Grey substance which extends to the sides of the head, which secrets over the top of and around and within the head and body.

9. Pink mist.

10. Yellow vesicles.*

11. Black vesicles at the bottom.*

Areas 1 and 2, which are actually one area, can require repeated breathing while expelling because they seem at times to struggle to re-establish themselves. The gold cylinder protrusion energy numbered 5 extends mainly into the lungs, which should be fanned over for it. The area numbered 3 may require repeated expelling for all eleven colours, as its mass can be excessive. Orange, yellow, red, and silver combine into 11 colours there.

Fever (Shown on page 198)

1. Black bar with green mist.

2. Intense yellow in the centre with long protrusions. This has a red centre which excretes over the encasement and into the body.

3. Pink area with grey rectangular protuberances around its edges.

4. Deep blue surrounding area.

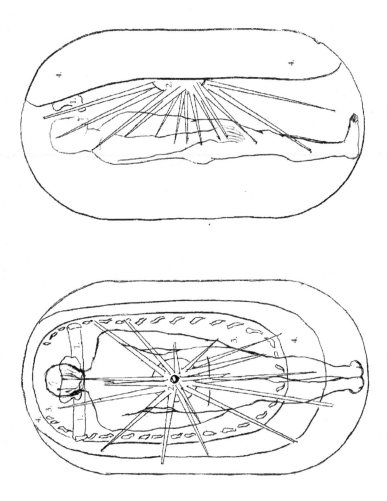

Notes

Chapter I

1) Manly P. Hall, *Lectures on Ancient Philosophy: Companion to the Secret Teachings of All Ages* (Los Angeles: Penguin Putnam Inc., 2006), pp. 289-92.

2) Gershom Scholem, *On the Mystical Shape of the Godhead: Basic Concepts in the Kabbalah*, tr. Joachim Neugroschel (New York: Schocken, 1991), p. 78.

Chapter II

1) The term 'active' is not used here as an opposite of 'reactive,' since all energy is considered to be, in some way, 'active.'

2) 'Taint' is used here in a sense now obsolete, which simply means to colour or tint, but with a special definition being applied here. It does not have the negative connotations this term usually takes.

Chapter III

1) Colour wheel of Robert Fludd, 'Colorum Annulus,' *Medicina Catholica* (Frankfurt, 1629).

2) Johann W. Goethe, *Theory of Colours*, tr. C. L. Eastlake (London: MIT, 1971), §793.

3) Yellow is a colour that can vary in mood, in terms of value. It can attain heights of value with its golden quality but, as artists know, can easily fall into yellows of intense or degraded expressions. Yellow is understood here as passive force regardless of its values, and is not withdrawal as forcelessness.

4) Carl G. Jung, *Collected Works*, tr. R.F.C. Hull (London: Routledge & Kegan Paul, Trench, Trubner & Co., 1940-), 12, *Psychology and Alchemy*, p. 189.

5) Friedrich Nietzsche, *Thus Spoke Zarathustra: A Book for Everyone and No One*, trans. R. J. Hollingdale (London: Penguin Classics, 1969), 3, "Of the Spirit of Gravity."

6) Martin Heidegger, *Nietzsche: Volumes One and Two*, II, "The Thought of Return as Belief," pp. 131-32.

7) Aleister Crowley, *The Holy Books of Thelema* (York Beach, ME: S. Weiser, 1983), *Liber Liberi vel Lapidis Lazuli*, III:13.

8) Friedrich Nietzsche, *Thus Spoke Zarathustra*, 3, "The Convalescent," §2.

9) The term 'solipsistic' has special meaning here definable through an understanding of the alchemical solar realm and nature of the light described.

10) Carl G. Jung, *Collected Works*, tr. R.F.C. Hull (London: Routledge & Kegan Paul, Trench, Trubner & Co., 1940-), 12, *Psychology and Alchemy*, pp. 55-57.

Chapter IV

1) Sophocles, *Oedipus Rex*, line 867.

2) Thomas Vaughan (Eugenius Philalethes, pseud.), *Anthroposophia Theomagica: or a Discourse of the Nature of Man and his State after Death* (London: H. Blunden at the Castle at Corne-hill, 1650), from supplemental text *Anima Magica Abscondita*.

3) *Pharmakon* means 'drug.' The *pharmakeus* was a shamanic figure, and the *pharmakos* was a sacrificial victim chosen from slaves or criminals during times of plague or famine. The *pharmakeus* in ancient Greece was a sorcerer, a purifier and healer. Derrida characterises the *pharmakeus* as beneficial "insofar as he cures—and for that, venerated and cared for—harmful insofar as he incarnates the powers of evil—and for that, feared and treated with caution." (Jacques Derrida, *Dissemination*, tr. Barbara Johnson (London: Athlone, 1981), p. 133.) In early alchemy *pharmakon*, 'drug,' was "a common term for the

preparation meant to colour metals," notes Jack Lindsay. This may have been closely related to the egg-vessel: "Greek texts deal with the Parts of the Egg and show that attempts were made to assimilate or classify all the materials of alchemy as these parts." (Jack Lindsay, *The Origins of Alchemy in Graeco-Roman Egypt* (New York: Barnes & Noble, 1970), pp. 186-87.)

4) Jack Lindsay, *The Clashing Rocks: A Study of Early Greek Religion and Culture and the Origins of Drama* (London: Chapman & Hall, 1965), p. 321.

5) Karl Kerényi, *Dionysos: Archetypal Image of Indestructible Life*, tr. Ralph Manheim (Princeton: Princeton University Press, 1976), p. 34.

6) Aleister Crowley, *777: Qabalistic Tables of Correspondenses*, Revised by the Master Therion, privately printed by the O.T.O., p. 75.

7) Gershom Scholem, *On the Mystical Shape of the Godhead: Basic Concepts in the Kabbalah*, pp. 318-19n; referencing Rabbi Menahem Azariah Fano, *Ma'amar ha-Nefesh* (Pietrokow, 1903), pp. 3-10; and *Azarah Ma'amaroth* (Venice: 1597), *Ma'amar Hikkur Din*, pt. IV, chap. 14, f. 40a.

8) Ibid. p. 263.

9) Carl G. Jung, *Collected Works*, tr. R.F.C. Hull (London: Routledge & Kegan Paul, Trench, Trubner & Co., 1940-), 14, *Mysterium Coniunctionis*, p. 365.

10) Justice here refers to justification in a perspectival sense, as in the way a point or a line is justified or adjusted. It does not have moral or meaningful connotations, necessarily. Every perspectival position is always, somehow, 'justified.' It is intrinsically related to the way Heidegger understands the Greek *dikê* (justice) as simply 'jointure.' This jointure may then be interpreted as a circular jointure, and understood through Nietzsche's idea of the eternal return, or eternal recurrence. It may also be envisioned as the circular serpent, and the Ouroboros, or as Aion.

11) Martin Heidegger, *The Essence of Truth*, tr. Ted Saddler (London: Continuum, 2002), §28.

12) Friedrich Nietzsche, *Thus Spoke Zarathustra*, 1, "Of the Despisers of the Body."

13) Ibid., 4, "The Honey Offering."

14) Friedrich Nietzsche, *On the Genealogy of Morals & Ecce Homo*, tr. Walter Kaufmann (New York: Vintage, 1967), *Ecce Homo*, "*Thus Spoke Zarathustra*," §6.

15) Friedrich Nietzsche, *Twilight of the Idols: or, How to Philosophize with a Hammer; The Anti-Christ*, tr. R. J. Hollingdale (London: Viking Penguin, 1968), *The Anti-Christ*, §1.

16) Nietzsche, *Thus Spoke Zarathustra*, 3, "The Wanderer."

17) Friedrich Nietzsche, *Beyond Good and Evil: Prelude to a Philosophy of the Future*, tr. R. J. Hollingdale (Harmondsworth, Middlesex: Penguin, 1973), pp. 203-4.

Chapter V

1) See Jung, *Collected Works*, 12, *Psychology and Alchemy*, pp. 228-32.

2) Michael Maier, *Septimana philosophica* (Frankfurt: 1620).

3) See Carlos Castaneda, *Journey to Ixtlan: The Lessons of Don Juan* (New York: Washington Square, 1972), pp. 96-104.

4) Nietzsche, *On the Genealogy of Morals & Ecce Homo*, *Ecce Homo*, *Seventy-five Aphorisms from Five Volumes*, "On the Wanderer and His Shadow," §322.

5) 'The shadow pictures of the deceased';
'the feeble and impotent heads of the dead.'

6) Arthur Schopenhauer, *Parerga and Paralipomena*, "Essay on Spirit Seeing," vol. 1 (Oxford: Clarendon Press, 1974), p. 284.

7) Carlos Castaneda, *The Eagle's Gift* (New York: Washington Square, 1991), p. 289.

8) See Goossen Van Vreeswijk, *De Goude Leeuw, of den Asyjn der Wysen* (Amsterdam: Joh. Janssonius van Waesberge, 1676).

9) See *Rosarium philosophorum sive pretiosissimum donum Dei, De Alchimia Opuscula complura veterum philosophorum* (Frankfurt: 1550).

10) Carlos Castaneda, *The Power of Silence: Further Lessons of Don Juan* (New York: Washington Square, 1991), pp. 184-95. In Castaneda death appears as an apparition, an advisor, and as our only challenger-opponent. Also, pp. 111-12. Also see, for example, Alexander Roob, *Alchemy and Mysticism: The Hermetic Museum* (Koln: Taschen, 1997), section on "Resurrection," and p. 518; in reference to an image from Thomas Aquinas (pseud.), *Tractatus qui dicitur Thomae Aquinatis de alchimia* (1520): "Death and corruption are the key to higher life, the fundament and source of the whole Work."

11) *Techné* may be translated, somewhat naively, as art or technique. It refers to the knowledge and mechanism of something that brings something about, so to speak. Heidegger understands *techné* as the knowledge that sustains and guides *phusis*. But *phusis*, from which our term 'physical' derives, was experienced as something dreamlike or magical by the early Greek. It was also "self-blossoming emergence (e.g. the blossoming of a rose)," according to Heidegger. (*An Introduction to Metaphysics*, tr. Ralph Manheim (New Haven: Yale University Press, 1959), p. 11.) Magicians received the name *phusicoi*, according to Marcel Mauss. (*A General Theory of Magic*, tr. Robert Brian (London: Routledge & Kegan Paul, 1972.) Therefore the term *techné* may appropriately be used to describe occult arts and practice.

12) *Logos* is a Greek word with a history of interpretations. It is usually associated with words and language, and logic, though Heidegger notes that originally the Greek *logos* stood in "no direct relation to language." (Heidegger, *An Introduction to Metaphysics*, pp. 104-5.) It

may be understood here as the gathering and constellation of images in the psyche.

13) The *phronimos* possesses sagacity and discernment. This term derives from the root *phrên*, a term that described the midriff area of the body.

14) David Wiles, *Tragedy in Athens: Performance Space and Theatrical Meaning* (New York: Cambridge University Press, 1997), pp. 76-77.

15) Ibid.

16) Manly P. Hall, *The Occult Anatomy of Man* (Los Angeles: The Philosophical Research Society, 1957), p. 15.

17) The idea of serenity has a broad and extensive context here. It has basis in the Greek *sophrosunê*, which derives from the root *phrên*. It has various parallels in the history of philosophy. The Nietzschean joy may be seen as related to this serenity, as may Spinoza's joy. It may also be related to the Christian grace, or to the Hebrew *shalom*, particularly in its original forms. The alchemical melancholy or saturnalia may also be interpreted as profound serenities.

Ruthlessness in Castaneda's work is a mysterious state of being related to the extraordinary, that is also perhaps a type of serenity. And it is also true that Heideggerian *Angst*, in its authentic form, is a type of serenity.

18) Nietzsche, *Thus Spoke Zarathustra*, 1, "Of Joys and Passions."

19) Ibid., 2, "Of the Virtuous."

20) Castaneda, *The Eagle's Gift*, p. 136.

21) Nietzsche, *Thus Spoke Zarathustra*, 3, "On the Mount of Olives."

22) The Greek *apatheia* is a form of the term *pathos*, usually understood as a privative form. It denotes freedom from emotion, or *pathos*, and is related to the English 'apathy.' It is given a meaning here, however, that is particular to this alchemical vessel and its light.

23) Franz Hartmann, M.D., *Magic White and Black: Practical Hints for Students of Occultism* (London: Aquarian, 1969), pp. 212-13.

24) Michael Maier, *Atalanta Fugiens*, Emblem XXIX.

25) See Nicolas Barnaud Delphinas, *Triga chemica: de lapide philosophico tractatus tres*, or *The Book of Lambspring* (Leiden: 1599).

26) Nietzsche, *Thus Spoke Zarathustra*, 3, "The Convalescent," §2.

27) See Nietzsche, *Thus Spoke Zarathustra*, 3, "Of Involuntary Bliss," "The Apostates," "The Three Evil Things," "The Convalescent," and 4, "Conversation with Kings."

28) Nietzsche, *Thus Spoke Zarathustra*, 4, "The Song of Melancholy," §3.

29) Jung, *Collected Works*, 11, *Psychology and Religion: West and East*, pp. 177-78.

30) Ibid., 9, part 1, *The Archetypes and the Collective Unconscious*, p. 331n.

31) Ibid., 12, *Psychology and Alchemy*, p. 162n, ref. Petrus Bonus, *Petriosa margarita novella* (Lacinius edition, 1546).

32) Ibid., p. 317.

33) Solomon Trismosin, *Splendor Solis* (1582), British Library, MS Harley 3469. Plate 9 depicts the Rebis holding the mirror and the egg.

Chapter VI

1) Jung, *Collected Works*, 12, *Psycholgy and Alchemy*, p. 190.

2) Carl G. Jung, *The Integration of the Personality*, tr. Stanley M. Dell (London: Kegan Paul, 1940), p. 174. Also see Jung, *Collected Works*, 12, *Psychology and Alchemy*, dream 24, on quartz crystals and the diamond.

3) Scholem, *On the Mystical Shape of the Godhead*, p. 266. See also chapter 6 on the astral body.

Appendix

1) Walter F. Otto, *Dionysus Myth and Cult*, tr. Robert B. Palmer (London: Indiana University Press, 1965), pp. 38-39.

2) John G. Bourke, *Apache Medicine Men* (New York: Dover, 1993).

Josephine McCarthy's Magical Knowledge Trilogy

Order direct from

online at - www.mandrake.uk.net

Email: mandrake@mandrake.uk.net